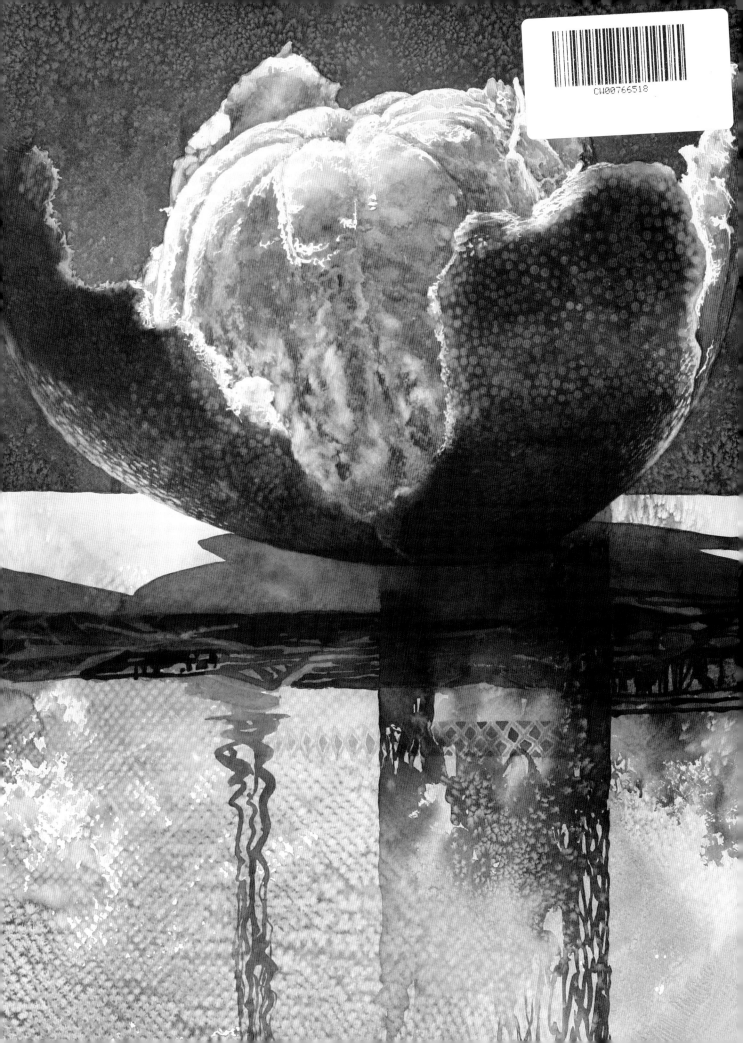

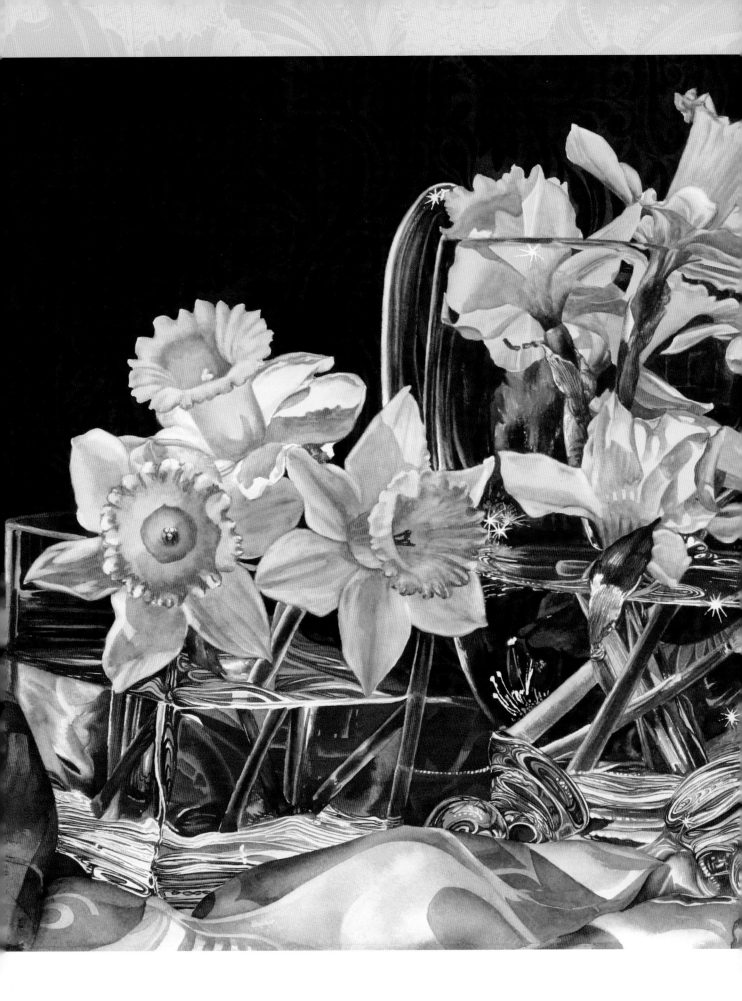

Painting Vibrant WATERCOLORS

discover the magic of light, color and contrast

Soon Y. Warren

NORTH LIGHT BOOKS
CINCINNATI, OHIO
www.artistsnetwork.com

 Other fine North Light Books are available from your local bookstore, art supply store or online supplier. Visit us at our website www.fwmedia.com.

15 14 13 12 11 5 4 3 2 1

DISTRIBUTED IN CANADA BY FRASER DIRECT
100 Armstrong Avenue
Georgetown, ON, Canada L7G 5S4
Tel: (905) 877-4411

DISTRIBUTED IN THE U.K. AND EUROPE BY F&W MEDIA
INTERNATIONAL, LTD
Brunel House, Forde Close, Newton Abbot, Devon, TQ12 4PU,
England
Tel: (+44) 1626 323200, Fax: (+44) 1626 323319
Email: enquiriers@fwmedia.com

DISTRIBUTED IN AUSTRALIA BY CAPRICORN LINK
P.O. Box 704, S. Windsor NSW, 2756 Australia
Tel: (02) 4577-3555

Congress has cataloged hardcover edition as follows:
Warren, Soon Y.
Painting vibrant watercolors : discover the magic of light,
color and contrast / Soon Y. Warren.
p. cm.
Includes index.
ISBN 978-1-60061-112-4 (hardcover : alk. paper)
1. Watercolor painting--Technique. I. Title.
ND2420.W354 2009
751.42'2--dc22 2008043817
ISBN: 978-1-4403-1472-8 (pbk. : alk paper)

Edited by Stefanie Laufersweiler
Production edited by Kelly Messerly and Jennifer Lepore Brune
Designed by Guy Kelly
Production coordinated by Matthew Wagner

Art on cover:
Bing Cherries
Watercolor on Arches 300-lb. (640gsm) cold press
22" x 30" (53cm x 76cm)

Art on page 1:
Small Clementine
Watercolor on Arches 300-lb. (640gsm) cold press
30" x 22" (76cm x 53cm)

Art on pages 2–3:
Daffodils and Glass
Watercolor on Arches 300-lb. (640gsm) cold press
22" x 30" (53cm x 76cm)

ACKNOWLEDGMENTS
My most sincere thanks go to the North Light Books staff (magic people!), who worked hard to put together the materials I delivered for this book. Specifically, I'd like to thank publisher and acquisition editor Jamie Markle, who helped me develop the book idea, and editor Jeff Blocksidge, who helped me get started and guided me in developing the book's details. I also thank editors Kelly Messerly and Stefanie Laufersweiler; copyeditor Nancy Harward and proofreader Roseann Biederman; designer Guy Kelly, and production coordinator Matthew Wagner, who made sure everything looked good through the final process of printing the book.

My sincere, special thanks go to my husband, Peter, who understands my English as a second language better than anyone, and who took charge of the care of the new additions to our family, my niece and nephew Hae Lin and Hae Seong. With support and love, he did all the proofreading and editing to create the final manuscript so my editor could understand my words from the initial proposal to the final version of the book. Without him, it would have been impossible for me to complete the book.

DEDICATION
I dedicate this book to the memory of my mother, Hong SaNam, and to my loving husband, Peter.

Metric Conversion Chart

To convert	to	multiply by
Inches	Centimeters	2.54
Centimeters	Inches	0.4
Feet	Centimeters	30.5
Centimeters	Feet	0.03
Yards	Meters	0.9
Meters	Yards	1.1

Tulips in the Garden
Watercolor on Arches 300-lb. (640gsm) cold press
22" x 30" (53cm x 76cm)

ABOUT THE AUTHOR

Soon Y. Warren was born in South Korea and immigrated to the United States in 1987. Soon's favorite subjects are those found in nature, which inspire in everyday life. "I'm inspired by the beauty and complexity of nature and our surroundings," she says. "I try to paint the essence of my subjects using my sincere feelings for nature."

Since Soon Y. began painting full time in 1998, she has had many exhibitions and earned numerous awards. She is a signature member of the National Watercolor Society (NWS), the Southern Watercolor Society (SWS), the Society of Watercolor Artists (SWA) and the Texas Watercolor Society (TWS)–Purple Sage Brush Society.

Her paintings won awards and were published in 2005 and 2006 competitions sponsored by *Watercolor Artist* magazine (formerly *Watercolor Magic*) and *The Artist's Magazine*. She is one of the featured artists in *Splash 8: Watercolor Discoveries* and *Splash 10: Passionate Brushstrokes*. Soon Y. is also the author of *Vibrant Flowers in Watercolor*.

Table of Contents

Tower in Venice
Watercolor on Arches 300-lb. (640gsm) cold press
30" x 22" (76cm x 56cm)

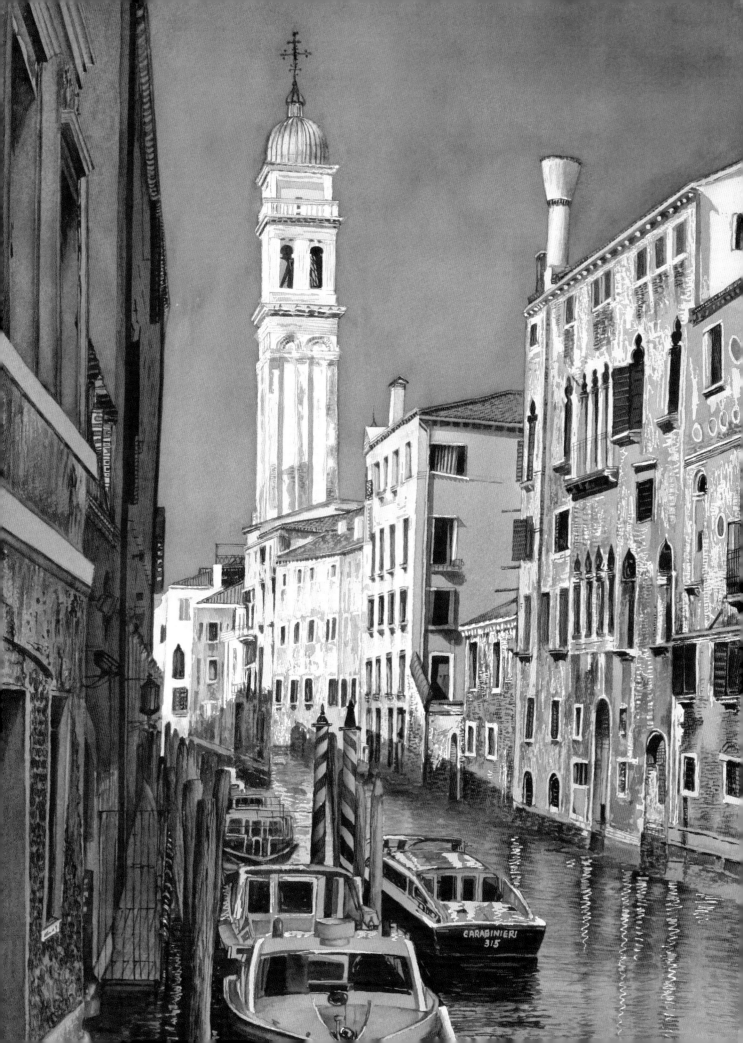

Introduction

People often comment how hard it is to paint with watercolor, or ask me how hard it is. I say, "It's not!" Painting with watercolor is as simple and uncomplicated as any other medium. With but a little planning and patience, watercolor is easy to handle and surprisingly flexible if you need to switch gears when your original plan isn't working.

There are no magic formulas to learn how to paint. Painting does not lend itself to an exact 1 + 2 = 3 formula or a regular 1-2-3 step-by-step process. Every individual paints differently, even when painting from exactly the same source, so have fun trying different approaches to a new painting.

The demonstrations in this book will show you how to take advantage of the versatility of watercolor to create deep and vibrant colors, layer by layer. You will also see how to best use a light source to create various moods, and how to incorporate contrast to make your paintings sparkle.

Also, you will be introduced to some different mediums that you can pair with transparent watercolor for fun, creative and surprising results that will spice up your paintings. Most of the paintings use only transparent watercolor, however. If you can adopt the ideas and processes they show, or derive different ideas and processes from them, then success is at hand. Try adding other mediums when you seek inspiration and want to push a painting further.

When you plunge into watercolor painting, you will learn the uniqueness of the medium. With that knowledge, you can gain control of your craft and hone your ability to express your unique artistic vision. Knowledge gives you the freedom to be creative and to discover who you are as an artist. The feelings in your heart and the touch of your hand create the artistic magic that only you can recognize until you put it down on paper. Use your heart and hand to lead the rest of us into a new world of artistic creation and discovery!

Sunny Side Windows
Watercolor on Arches 300-lb. (640gsm) cold press
30" x 22" (76cm x 56cm)

Spoonful of Sugar
Watercolor on 140-lb. (300gsm) cold press
21" x 29" (53cm x 74cm)

CHAPTER 1

Painting Materials

We artists tend to feel bombarded by an endless variety of wonderful painting supplies—both those that have been on the market for years and those that have been invented more recently. Instead of trying to work around short supplies, we are more likely faced with the challenge of narrowing the array of what's available to only what we truly need, and determining which products work better than others. Of course, we might be more familiar with the pros and cons of older products, and therefore more comfortable with them. But when eyeing a display of new art supplies, it's hard not to become another kid in the candy store.

If the options overwhelm you, remember that all materials are simply tools to help you express your artistic mind. When you find a product that suits your ideas and methods, don't hesitate to use it. In this chapter, I list the basic tools you need to paint in watercolor, and then talk a little about other water mediums you can use to enhance your watercolors. The way to understand new materials is to try them, so make sure you do. That is the best and most effective way to discover whether the new medium will suit your work. Lastly, appreciate all the supplies you already have! Never forget that you can always use these products to create something artistically different.

Watercolor Paints

Many different companies produce watercolor paints, and each company's colors have unique characteristics. Deciding which colors best suit you and your style takes time. Experience will make you more confident with your choices. Try as many colors as possible, but use them selectively to create the mood you want for each painting. I cannot emphasize enough that you should learn to *feel* the colors instead of academically applying them. The colors on your palette should act through you to make your paintings. Don't be afraid of mistakes when mixing colors, even muddy mistakes. Trial and error is the best way to get a feel for how color works.

I prefer to buy paints with good lightfastness ratings, meaning their colors stand up well to the test of time and resist fading. Manufacturers usually indicate their ratings right on the paint tubes, and in the technical information pamphlet available from the manufacturer. I usually consult *The Wilcox Guide to the Best Watercolor Paints*. Paints that have the best lightfastness ratings don't always have the most brilliant color, but I prefer them because the color will last longer. The easiest way to keep track of your paints is to use only those with excellent ratings.

Also, it's usually best to invest in professional-grade paints instead of the less expensive student- or academy-grade paints. Professional-grade paints tend to be of finer quality and will produce cleaner and more intense colors than the student grades. Using better paints will give you better results in your paintings. Even if you're a beginner, they're worth the extra cost. A tube of paint will last quite long, even if you paint every day.

WATER TO PIGMENT RELATIONSHIP

When you understand how watercolor pigment works with water, painting becomes less stressful and more exciting. Think of water as the boss and watercolor pigments as

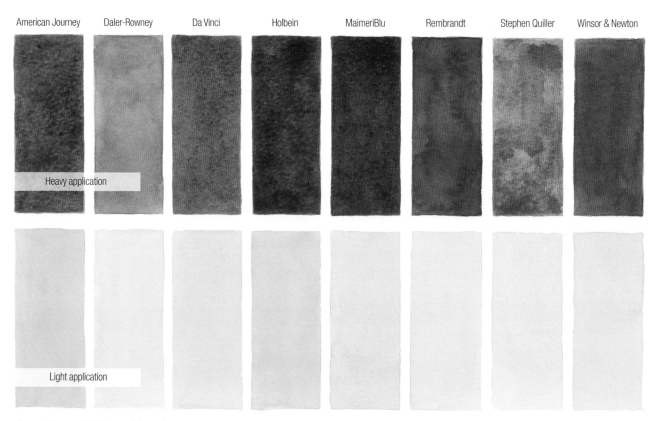

| American Journey | Daler-Rowney | Da Vinci | Holbein | MaimeriBlu | Rembrandt | Stephen Quiller | Winsor & Newton |

Heavy application

Light application

Same Name, Different Manufacturer
Paint pigments and formulations vary among manufacturers. For example, these colors all share the same name, Hooker's Green, but visibly vary. The differences may be subtle or dramatic, as shown here. This can be frustrating when you're trying to achieve specific mixtures of different colors. As you paint, you'll find which colors work best for you. Until then, keep in mind that the same name doesn't mean that the colors are identical from company to company.

obedient servants, submissive to the water. You don't have to use a brush to physically mix and mingle water and pigment. Simply drop the paint onto wet paper and the magic happens: the water tells the pigment exactly where to go!

TRANSPARENT VS. OPAQUE PIGMENT

Transparent pigment is color through which the paper or underlying layers of paint can be seen. Transparency greatly affects the look of a painting. Light can pass through transparent glazes and bounce off the white of the paper, allowing you to see multiple colors at once. For example, with a first layer of yellow and a second of blue, the resulting color is a beautiful, luminescent green. Glazing transparent colors can create a variety of values and hues.

Opaque pigments are paints that you can't see through when they're applied. They have varying degrees of opacity, from semiopaque to completely opaque. You will notice that opaque colors have a slightly chalky texture when you mix them with water on the palette. Those noticeably chalky granules are what obstruct light's penetration to the paper's surface. Light bounces off the surface of the pigment, not the paper, so all you see is the opaque color.

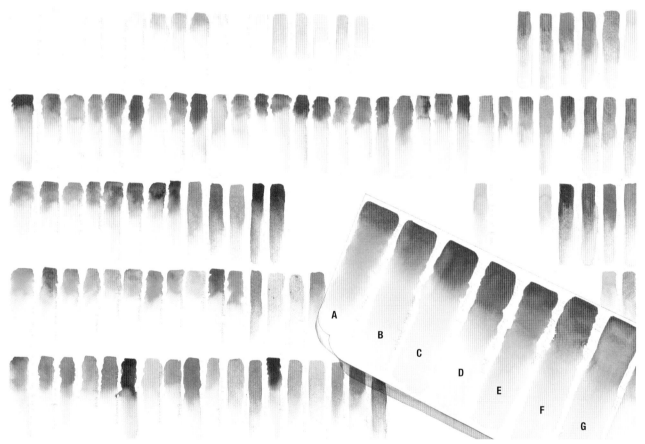

Personal Color Chart

Make yourself a color chart like this one to help you see the subtle differences among similar colors of different names or brands. Whenever you purchase a new paint, add it to your chart. Use at least a half sheet of paper (15" x 22" [38cm x 56cm]) for your chart, so you will be able to add new colors on the same sheet rather than accumulating a collection of small pieces. Next to each color, note the manufacturer and color name. For your chart, use the watercolor paper that you use the most often, so you will better know what to expect to see in your future paintings.

When painting these strips of color, be sure to have one end heavily diluted and the other much less so. This way, when you start thinking about a color's value, you can consult your color chart to see the paint's range from light to dark.

A. Alizarin Crimson (American Journey)
B. Cadmium Red Purple (HWC)
C. Permanent Alizarin Crimson (Winsor & Newton)
D. Permanent Red (HWC)
E. Permanent Rose (Winsor & Newton)
F. Quinacridone Red (Winsor & Newton)
G. Quinacridone Rose (Daniel Smith)

Opaque colors feel heavier and thicker on the surface of your paper. Incorporate them into your painting to make transparent colors appear more vivid, to cover up minor mistakes or for final touch-ups and details.

STAINING VS. NONSTAINING

Some paints are made of pigments that actually bond with the paper, making them harder to remove. These are referred to as *staining colors*. Staining colors leave a visible residue if you try to scrub them off your paper. They are particularly good for mixing dark colors.

Many nonstaining colors have opaque characteristics to a greater or lesser degree, but they will not react with the paper; nonstaining paints simply leave a coating. These colors are very easily removed from a painting. Even staining color, however, lifts off the paper's surface with harsh scrubbing.

Try not to scrub too much; even if it's nonstaining paint, the surface might be disturbed or torn. Paint applied to paper that's been over-scrubbed never looks quite right, especially on the lighter areas of your paintings.

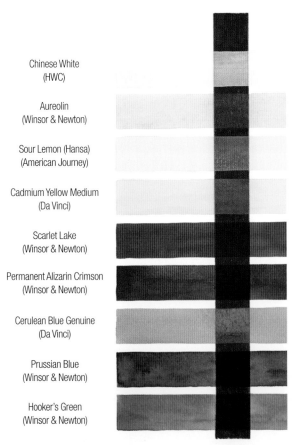

Chinese White (HWC)

Aureolin (Winsor & Newton)

Sour Lemon (Hansa) (American Journey)

Cadmium Yellow Medium (Da Vinci)

Scarlet Lake (Winsor & Newton)

Permanent Alizarin Crimson (Winsor & Newton)

Cerulean Blue Genuine (Da Vinci)

Prussian Blue (Winsor & Newton)

Hooker's Green (Winsor & Newton)

Transparent vs. Opaque

Here's a method of testing a color for opacity or transparency. Draw a solid, vertical half-inch (13mm) black line with a permanent marker down the center of a piece of paper. Paint a horizontal, solid block of the color you want to test across the black line. Opaque colors leave a white residue on the black area after they dry. If the color intensifies the marker without leaving a white residue, it is transparent.

Aureolin (Winsor & Newton)

Quinacridone Gold (Winsor & Newton)

Scarlet Lake (Winsor & Newton)

Permanent Alizarin Crimson (Winsor & Newton)

Sap Green (Daler-Rowney)

Winsor Green (Blue Shade) (Winsor & Newton)

French Ultramarine (Daniel Smith)

Winsor Blue (Green Shade) (Winsor & Newton)

Staining vs. Nonstaining

Some pigments actually bond to paper (staining), while others leave a coat of color that lifts off the paper more easily (nonstaining).

Transparent Color Mixing

Overall, transparent mixed colors are lighter and sharper than opaque mixed colors. They feel delicate, clean and subtle and are perfect for glazing. Transparent colors will not muddy the glaze.

Opaque Color Mixing

Mixing opaque colors results in beautiful, clean color, but creates a heavier, more intense look. They are not ideal for glazing because the chalky pigments will lift off when you glaze over with them with different colors. Also, be careful when you mix more than three hues. This increases the chance that you will make a muddy, dull, low-intensity color.

Tertiary Color Mixing

Manufacturers premix many beautiful secondary and tertiary tube colors that are very tempting to add to the colors on your palette. Using a tertiary hue as-is from the tube or mixing it with a similar primary hue usually produces a clean color, but mixing it with another tertiary color results in a muddy color. Set aside tubes of tertiary colors for special occasions.

Dark Color Mixing

Using dark colors helps to create contrast in a painting, setting off lighter colors. To mix a dark color, it is essential to use transparent colors. Opaque colors, due to their chalkiness, tend to reflect white light back to the viewer, which makes a dark color appear lighter.

Other Useful Water Mediums

Expanding your knowledge of the uses of other water mediums will help you be a little more daring and adventurous. Once you learn that there is always a way to salvage a painting you thought was lost because of the limitations of transparent watercolor, you will feel less inhibited about experimenting. This section covers other water-based mediums and how using them can benefit your watercolors.

GOUACHE

Gouache is simply very opaque watercolor. The pigment used to make it is drier, thicker and heavier, with white chalk that increases its opacity. Unlike with transparent watercolor, you add white paint to gouache to create lighter colors, rather than thin-ning it with water and reserving the white of the paper.

The opacity of gouache significantly limits its usefulness for layering or glazing. Attempting to add a layer will easily disturb the previous layer. However, gouache is very helpful to revitalize a watercolor painting that has lost its whites through over-painting or excessive scrubbing. Gouache can help you reclaim these areas.

ACRYLIC PAINT

Liquid or fluid acrylics—those made by Golden in particular—are highly intense, permanent colors with a consistency similar to heavy cream. They offer fine dispersion of pigment, high tinting strength, durability, flexibility and good adhesion.

Fluid acrylics are useful for creating smooth washes, especially overall washes at the beginning of a painting. Because of their permanence, you can apply layer upon layer (including alternating with layers of watercolor) without disturbing previous layers.

Tube acrylics are heavy-bodied and fast-drying. It is possible to dilute fresh acrylics with water, but they are completely water-resistant once dry. Depending on how diluted the paint is with water—or modified with acrylic gels, mediums or pastes—a finished acrylic painting can resemble a watercolor or an oil painting, or have its own unique characteristics not attainable with any other mediums. Tube acrylics can help you reclaim the lighter areas you've lost

Gouache

- follows the water very quickly when diluted.
- feels smooth to the touch with a brush.
- appears flat because of its opacity. A light hue stands out without fading into the dark background.
- is easy to lift off, whether dried or freshly applied.
- dries as fast as watercolor.
- is useful for reclaiming lost white or light areas.

Tube Acrylic

- doesn't follow the water nicely unless pushed or spread with a brush.
- feels slick to the touch with a brush.
- can appear transparent, semi-opaque or opaque, depending on how diluted the pigment is.
- is permanent after it dries and will not lift at all.
- dries as fast as watercolor.
- is useful for reclaiming lost light areas or completely revamping a watercolor painting.

in a watercolor, or you can use them to reinvigorate or reinvent a so-so watercolor piece.

INDIA INK

India ink, also called Chinese ink, is a simple black ink used for writing and painting in east Asia. The ink is water-resistant, so it is a wonderful medium for incorporating texture when using a dry-brush technique. Use it to add texture to shadows or other already dark areas. Take great care when using India ink, however; once applied, it is permanent and you cannot remove it.

METALLIC POWDER

Introducing gold powder into a composition can help add sparkle to a painting in progress, or give new life to an old piece you feel is dull or weak. It transforms once dull, matte surfaces into shining areas of interest. You can plan gold designs or touches at the beginning of the painting process, or you might decide at the end to add gold drawings or shapes. You can add gold powder at any time, but remember that once it's applied, the surface underneath it becomes waterproof and your ability to add another color on top of the gold will be limited.

Light reflected by gold powder is different from light reflected by the white of the paper. The surface painted with gold powder reflects color and refracts light from the surrounding colors. The visual effect changes as you view the painting from different angles. Light reflected by plain or glazed white paper is sharper and more consistent as you view the painting from different angles.

Usually, manufacturers instruct artists to mix metallic powder with water only. However, my experience with water alone was not successful, as it did not bind the powder to the paper well as the mixture dried. To prevent the powder from flaking off after the painting dries, use a mixture of half water and half matte or gloss acrylic medium. This thinned mixture will be smooth enough for a brush to move it freely, yet it will adhere well once it dries.

Besides rich and pale golds, there are several different metallic powders available, including bronze, copper and silver. Experiment with all of the colors to find the ones that best suit your creative needs.

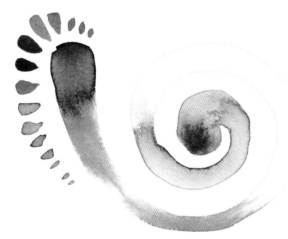

Liquid Acrylic

- follows the water very aggressively, whether full strength or diluted.
- feels slick to the touch with a brush.
- appears more transparent.
- is permanent after it dries.
- dries as fast as watercolor.
- is useful for creating smooth washes that won't lift when subsequent layers are applied.

India Ink

- follows the water very slowly whether full strength or diluted.
- feels the same as transparent watercolor with a brush.
- appears more transparent than opaque black paint.
- is permanent after it dries.
- dries as fast as watercolor.
- is useful for dry-brush technique to create texture.

Palettes

Setting up your palette is a matter of personal preference. Remember that the colors you choose is what matters most. I change my palette as I lose interest in some older colors and as I gain experience with new colors, or even just to try some new color that I might like.

Arrange your palette with the colors that you use the most in the most convenient location. Before you start to paint, squeeze only as much fresh color from the tube as you will need for your current painting session. Working with fresh color every time you paint will pay great dividends. Fresh paint is easy to use with soft brushes, and since fresh paint requires less agitation for mixing colors, the tips of your brushes will last longer, too. Completely dried-out paints lose their intensity, and can become gummy or grainy.

If your palette goes unused for only a short time, the paints may dry slightly but you can revitalize them. Before starting a new painting session, simply run the palette under a faucet to rinse off the previously mixed colors. Gentle, slow running water leaves the partially hardened paint on the palette. After rinsing the palette, let it sit for a while before starting to paint. Left-over water will soften the hardened globs of paint. If you need more color, add fresh paint to the palette just before you start to work.

Extra Palettes

Use old, unbreakable plates as extra palettes for major color groups, or for introducing new colors that you don't usually have on your palette. Corelle white dinner plates, for example, will not stain or slide around your painting table the way a foam plate will. Use one plate for bluish hues, one for reddish hues, one for greenish hues and another for yellowish hues. You also can use this type of plate for applying large washes when using a 3½-inch (89mm) hake brush.

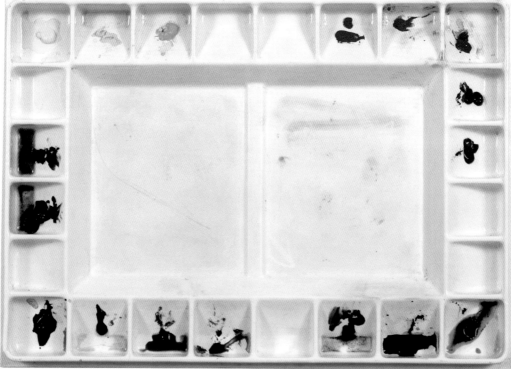

Sour Lemon (Hansa) (American Journey) — Aureolin (Winsor & Newton) — Cadmium Yellow Deep (Daler-Rowney) — Scarlet Lake (Winsor & Newton) — Cadmium Red (Winsor & Newton) — Quinacridone Red (Winsor & Newton) — Permanent Alizarin Crimson (Winsor & Newton) — Permanent Magenta (Winsor & Newton) — Burnt Sienna (American Journey) — Sepia (Winsor & Newton) — Winsor Green (Yellow Shade) (Winsor & Newton) — Indigo (HWC) — Prussian Blue (Winsor & Newton) — Ultramarine Blue (M. Graham) — Winsor Blue (Green Shade) (Winsor & Newton) — Sap Green (American Journey) — Hooker's Green (Winsor & Newton)

Setting Up Your Main Palette
Arrange your colors in this order: yellow, red, green, blue and earth colors. Notice the cool colors (green and blue) and warm colors (yellow and red) are on opposite sides of the palette to preventing accidental mingling. The earth colors are between the warm and cool colors. This arrangement of colors on your palette gives you the freedom to choose and mix slightly different colors right next to your primary hues while painting.

Paper

Watercolor paper is available in a variety of weights, such as 90-lb. (190gsm), 140-lb. (300gsm), 200-lb. (425gsm), 300-lb. (640gsm) and heavier. *Weight* refers to the weight in pounds for a 500-sheet ream of 22" × 30" (56cm × 76cm) paper.

The size of watercolor paper is generally consistent from company to company. A full sheet is 22" × 30" (56cm × 76cm). You can make half sheets yourself by cutting a full sheet into two 22" × 15" (56cm × 38cm) pieces.

There are also *blocks* of watercolor paper with all four sides of the paper glued together. You simply peel off one piece at a time. These are available in many different sizes. Unfortunately, you lose the deckled edges when using blocks. If you want sizes larger than 22" × 30" (56cm × 76cm) full sheets, you can find sheets that are 29" × 41" (74cm × 104cm), 40" × 60" (102cm × 152cm) and larger.

Different surface textures are available that will affect how paint appears once it is applied. These include hot press, cold press and rough press. Choosing types of paper is a personal preference. Test samples of each variety to find the surface you like the best.

Hot Press
Hot-press paper is smooth and slick. It's good for very fine detail and fine washes, but not for multiple glazes because the color from previous layers will lift off when subsequent layers are applied. For very fine washes, alternate watercolor with liquid acrylic so the color won't lift.

Cold Press
Cold-press paper has a medium texture: not too slick, not too bumpy. It accepts many glazes without the previous layers lifting. Cold-press paper is preferable for rich and vibrant paintings, because it's smooth enough for details yet rough enough to absorb plenty of water and color.

Rough Press
Rough-press paper is bumpy and has a rougher texture. It will absorb a large amount of water and color beautifully, so it is good for bold, large subjects that don't require tremendous detail.

Stretching Paper

Because paper can become saturated during the painting process—especially when you're freely spraying water or pouring color—you'll want to stretch the paper before you begin painting. Unstretched 140-lb. (300gsm) paper will buckle badly, and even heavier 300-lb. (640gsm) paper will curve.

Soak the paper in a bathtub for 15 to 20 minutes, until the paper is supple. Then lay the paper over ¼-inch (6mm) soft plywood and staple it around the edges. Let it dry for 24 hours or until completely dry, then cover the stapled edges with masking tape to prevent water from seeping in while you are painting.

Brushes

Brushes are the main tools for creating paintings. Choosing the right ones will make your painting process easier, cleaner and faster. A good rule of thumb is to choose a large brush when covering a larger area, and a small brush for smaller areas.

I mainly use round brushes because they are so versatile. They hold a lot of water and have pointed tips that can create thinner or wider brushstrokes. I recently discovered Silver Brush Black Velvet brushes, which serve my purpose well. You can usually use a no. 4 or 6 for very fine detail; nos. 8 and 10 for mid-sized detail and layering color; and nos. 12 and 16 for large-area application. A script liner is useful for making very thin, long lines.

Hake brushes are great for applying smooth, clean washes over large areas at the beginning of a painting. You will also want several different sizes for softening or maneuvering paint when working with wet-on-wet washes after applying the color to the paper.

You can also use old bristle brushes as scrub brushes to soften edges and lift mistakes.

For gouache and India ink, use the same brushes you use with watercolor. However, when using these brushes to apply acrylic-based mediums, clean them thoroughly when they will be idle for several minutes or longer. Rinse them as often as possible to prevent paint buildup.

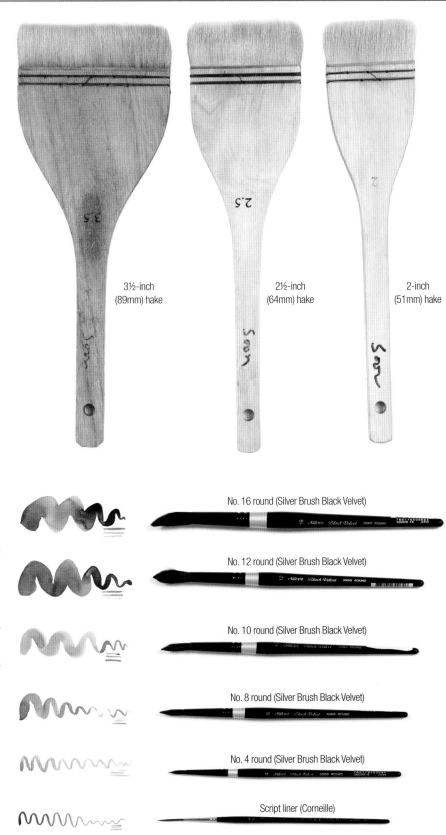

3½-inch (89mm) hake

2½-inch (64mm) hake

2-inch (51mm) hake

No. 16 round (Silver Brush Black Velvet)

No. 12 round (Silver Brush Black Velvet)

No. 10 round (Silver Brush Black Velvet)

No. 8 round (Silver Brush Black Velvet)

No. 4 round (Silver Brush Black Velvet)

Script liner (Corneille)

Other Supplies

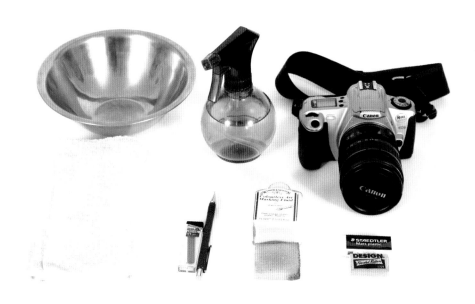

MECHANICAL PENCILS

For drawing, use a mechanical pencil with 0.5mm HB graphite. This lead is soft enough not to indent the paper and dark enough so you can easily see your drawing. In addition, you won't have to worry about maintaining a sharp point.

ERASERS

The Design kneaded rubber eraser from Sanford is good for general erasing on watercolor paper. The gummy texture will not scratch or buff the paper. Mars Plastic erasers from Staedtler are a good choice for erasing the sketch after finishing a painting. They are a little harder than rubber erasers and are better for thoroughly erasing pencil lines.

MASKING FLUID

It is not easy to save white lines or smaller spots for highlights when painting with watercolor, especially during the washing process at the beginning of the painting. Masking fluid can save you time and enhance the fluency of your painting (see the demonstration on page 47). Different companies call this product different names: Grumbacher calls it Miskit, Winsor & Newton calls it Colourless Art Masking Fluid, and Grafix uses the name Incredible White Mask.

Do not use your good brushes to apply masking fluid; it will dry on the brush and won't clean off. Use the tip of a brush handle or try toothpicks, which also work well.

Apply and remove masking fluid only after the paper has completely dried. Use rubber cement pickup to remove dried masking. Run a freshly washed hand over the painting to feel for any spots you may have missed, since they are not easily

visible. Left-over dried masking will feel sticky to the touch.

WATER BOWLS

Stainless steel mixing bowls work great for holding water. They're unbreakable, dishwasher safe, non-staining, and have a smooth rim that gently removes excess water from your brushes. Have several bowls of water on hand as you paint. You'll save time by not having to run to the sink to get clean water.

COTTON RAGS

Use 100-percent cotton cloths for your rags—the softer, the better. Try recycling old undershirts, cloth diapers or hand towels. Cotton rags absorb water better than paper towels and are inexpensive. To clean, machine-wash them separately from all other clothing.

SPRAY BOTTLE

Any spray bottle that will spray a fine mist would be wonderful for wetting large areas of your paper.

CAMERA

Use any camera that will capture the images that you like. Use an automatic SLR camera for quick, point-and-shoot shots. A manual SLR camera with a macro lens is ideal for capturing details and photographing still-life arrangements.

A digital camera might be a good investment for you. A 9-megapixel digital camera will give you approximately as much detail as a 35mm SLR camera using 100-speed film. A digital camera will let you see right away if you like the results, saving you excess photo processing costs.

Splendor of D.C. Fall
Watercolor on Arches 200-lb. (425gsm) cold press
25" x 39" (64cm x 99cm)

The Basics and Beyond

Before you start your next great work of art, let's review some of the most crucial elements of painting. Even if you think you already understand many concepts, you may find that the explanations in this chapter will clarify some ideas.

When I was very young, I remember thinking I was very good at drawing, so I drew and drew. I filled up a notebook with my drawings, and I treasured them. As time passed, I thought I was very good at using color on drawings, too, and I'd show them off to my close friends. Eventually, all those drawings and paintings that seemed great at the time no longer appeared as great as I remembered—because I had gained more knowledge and experience.

As I mature and grow older, I sometimes wonder what would have happened if I had stopped learning when I thought I was so good. Luckily, I thirst for knowledge and enjoy learning anything new, and I'll continue to do so until I set down my brush for the last time. I am so grateful and happy that I am still able to learn as I paint.

When I read a new book or article, I sometimes encounter theories that differ slightly from what I already know. Instead of helping me to understand, they can make me more confused. However, it is not theories or concepts that make your painting perfect—it is you who makes the paintings as individual as you are. As you look through this chapter, I hope you find some of the ideas refreshing. Remember that the fundamental techniques and theories only go so far. It is up to you to extend them and bend them.

Color Basics

Color is the most intuitively and expressively used element of painting, interpreted uniquely by each individual artist. When we first encounter a painting, we experience our overall feelings through color. The colors you choose to paint with can express emotion, set a mood or describe an attitude. Through color, you can convey the full spectrum of the conscious and subconscious human experience.

There are a few terms and concepts you should know to help you better understand color.

HUE

Hue is the name of the color produced by a pigment. Another term for hue is *color*. The proper definition of *hue*, however, is *pure color*; red, blue and green, for example, are hues. The term also is used as the name of a synthetic pigment made as a substitute for a natural pigment. For example, one manufacturer sells Gamboge Hue as a lightfast substitute for its non-lightfast Gamboge.

TEMPERATURE

The *temperature* of a color is its relative warmth or coolness when compared to other colors. Understanding the temperatures of colors affects how you mix them and where you place them in a painting. See page 27 for more on color temperature.

VALUE

Value, or *tone*, is a color's relative lightness or darkness. *Shade* refers to value gradations toward darkness and *tint* refers to gradations toward lightness. Strongly contrasting values, such as black and white, tend to be more visually exciting when placed next to each other in a painting. However, be judicious in your use of contrasting values; they can disrupt the unity of an image. See page 28 for more on value.

INTENSITY

Intensity, or *saturation*, refers to the purity of a color. A higher saturation implies greater color purity. Intense colors appear brighter than their

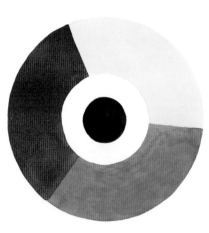

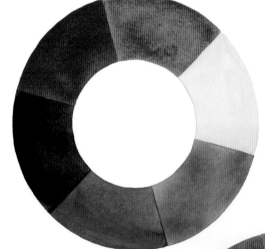

Secondary Colors
Secondary colors result from mixing two primary colors. Red mixed with yellow creates orange, red mixed with blue makes violet, and yellow mixed with blue produces green.

Primary Colors
There are three primary colors: yellow, red and blue. These three colors are pure; they cannot be created by mixing other colors together. If you mix equal parts of all three primaries, you'll produce black, but using two at a time, you can create an endless variety of colors.

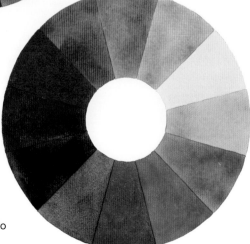

Tertiary Colors
Tertiary colors are produced when a primary and a secondary color are combined. These usually are created by mixing a primary with a secondary color that is adjacent to it on the color wheel.

duller, less saturated counterparts. See page 29 for more on intensity.

PRIMARY COLORS

The primary hues of the color wheel are red, yellow and blue. It is not possible to create these three hues by mixing any other colors. Mixing all three primaries together produces gray or black, depending on the ratios of paint mixed.

SECONDARY COLORS

The secondary colors—green, orange and violet—are the result of mixing two primary colors.

TERTIARY COLORS

Mixing a primary with a secondary color produces a tertiary color. For example, mixing blue and green gives you blue-green.

A Team of Tertiaries
The intense blue-violet iris stands in contrast to the mottled yellow-green background. Other tertiaries can be found in the yellow-green foliage and the yellow-orange and red-violet parts of the flower.

A Young Blossom
Watercolor on Winsor & Newton 140-lb. (300gsm) cold press
21" x 14" (53cm x 36cm)

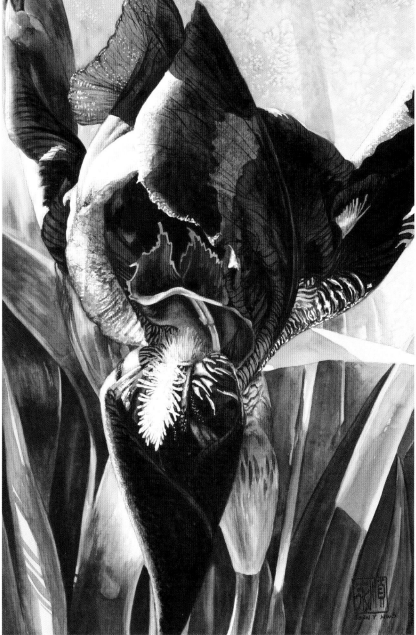

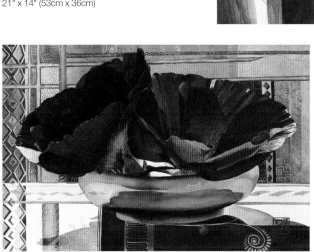

Primary Appeal
The primary colors in this piece—the red flowers, blue bowl and yellow background—are refreshing and just as eye-catching as typically more sophisticated secondary and tertiary color combinations. The background motif and the shadow use non-primary colors to create more interest and to soothe the eye.

Hollyhocks and Blue Bowl
Watercolor and gold powder on Winsor & Newton 140-lb. (300gsm) cold press
15" x 22" (38cm x 56cm)

Complementary Colors

Complementary colors appear on opposite sides of the color wheel: red and green, orange and blue, blue-green and red-orange, and so on. And, as the old adage goes, opposites do attract. Complementary colors placed side by side in a painting energize each other, forming a brilliant color combination that instantly attracts and dazzles the eye.

Mixing complementary colors together produces quite different results. Such mixtures range from grays to deep darks, depending on the saturation level of the paints. These mixtures may not be as dazzling as side-by-side complementary combinations, but they have a distinct advantage you can employ in your painting. Grays and dark colors created with complements are much more interesting and versatile than the boring shades of gray or black that come from a tube. The resulting mixtures—ranging from gray tints to rich darks—will have either a warm or cool nature, depending on the colors you use to mix them.

If you're uncertain how to pair complements in a painting, pay close attention to the colors you choose for your subject and consider using complementary colors for the background. Remember, too, that not every complementary combination needs to be bold to be effective. For instance, you might decide that pale violet and yellow are perfect for setting a quiet yet intriguing mood.

When Complements Mix

blue + orange

green + red

violet + yellow

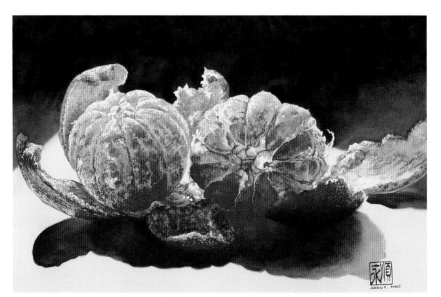

Complements Make Quite a Pair
These fresh tangerines appear all the more tantalizing when juxtaposed with dark blue. Place a reddish piece of paper over the background to see how they would look without the complementary color: less intense and more muted.

Tangerines
Watercolor on Winsor & Newton 140-lb. (300gsm) cold press
14" x 21" (36cm x 53cm)

Although yellow and red are naturally warm, and blue is the cool one among the primary colors, each primary hue has its warm and cool versions. Cadmium Yellow is warmer than Lemon Yellow, for instance; Scarlet Lake is warmer than Alizarin Crimson; Ultramarine Blue is warmer than Cerulean Blue.

Recognizing primary hues as either warm or cool enables you to mix more highly saturated secondary colors. If you incorrectly guess the temperatures of the colors you're mixing, you will limit the vibrancy of the resulting mixtures. Mixing warm primaries with cool ones will lead to subtle differences in intensity and cleanliness of the resulting secondary colors. However, if you mix warm colors with warm shades of cool colors, you will produce clean, brilliant, more vibrant colors.

Some companies clearly label colors with cool or warm temperature ratings. For instance, Winsor & Newton makes two types of Winsor Blue: a warmer one with a warmer red shade and a cooler one with a green shade.

It is possible to mix most of your own vibrant colors using primary hues. However, with a great range of quality paints available, it is convenient to use some premixed colors, such as Sap Green, Burnt Sienna, Indigo and Sepia. Remember that using muted, less saturated colors will help more intense adjacent colors shine.

EFFECTS OF TEMPERATURE

Optically, warm colors such as red, orange and yellow seem to advance toward you, while cool colors like blue, green and blue-violet recede. Use cool colors in shaded areas to create the illusion of distance. This plays an especially large role in representational painting, where your goal is to re-create your subject three-dimensionally on paper.

Psychologically, warm colors inspire cheerful, happy and positive feelings, while cool colors suggest calm, serene and quiet feelings, or maybe even a somber mood.

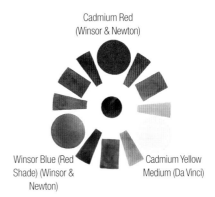

Cadmium Red
(Winsor & Newton)

Winsor Blue (Red Shade) (Winsor & Newton)

Cadmium Yellow Medium (Da Vinci)

Mixing Warm Primaries
Re-create this color wheel by mixing the warm primaries shown. Notice how the mixes on the warmer side of the wheel appear cleaner than the slightly muddied colors on the cool side.

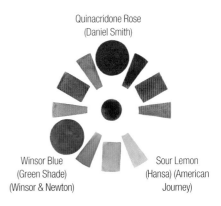

Quinacridone Rose
(Daniel Smith)

Winsor Blue (Green Shade) (Winsor & Newton)

Sour Lemon (Hansa) (American Journey)

Mixing Cool Primaries
In contrast mixing cool primaries produces clean, sharp colors on the generally cool side of the color wheel. However, the resulting secondaries and tertiaries on the warmer side of the wheel are not as brilliant.

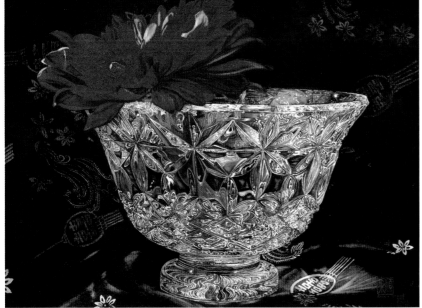

Warm Colors Come Forward, Cool Colors Recede
This zinnia may be small and off center, but the cool blue surrounding it pushes the warm red flower forward, allowing it to dominate the viewer's first impression of the painting. The only other sources of warm color are a little yellow and red reflected in the crystal.

Red Zinnia
Watercolor on Arches 300-lb. (640gsm) cold press
22" x 30" (56cm x 76cm)

Value

The value (relative lightness or darkness) of a color depends on how much light reflects from that color. A greater amount of reflected light results in a higher or lighter value, while less reflected light produces a lower or darker value. For example, white, the lightest value, reflects a lot of light, while black, the darkest value, absorbs a lot of light.

VALUE VS. COLOR

Remember that color is not the same thing as value. Black-and-white photos and other value-study tools, such as red acetate, reduce images to values only. For instance, a dark blue or red may appear black in a black-and-white photo. Yellows, on the other hand, have an inherently light value and will never appear as dark as black.

In watercolor, lighter values are created by diluting a paint with water. This allows the lighter value of the white paper to shine through. Use diluted paints for lighter areas and thicker paints for darker areas. Keep in mind as you paint that naturally light colors will have shorter value ranges, or a less noticeable difference from value to value, than those that are naturally dark.

TINTS VS. SHADES

The values of tints and shades differ from the value of the original hue. You can create lighter and lighter tints of a color by diluting the paint with more and more water. Keep in mind that the lighter the tint you produce, the more the original color loses intensity as well as value. Darker shades are made by adding black or a dark color to any hue. The value of the original hue will always be lighter than the value of its shades. Adding

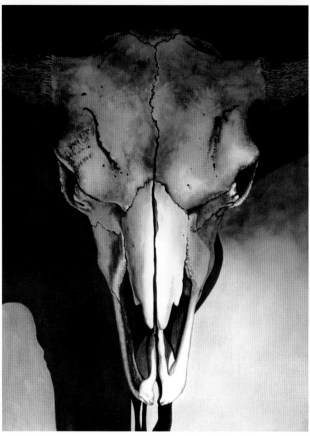

Once Upon a Time
Watercolor on Arches 300-lb. (640gsm) cold press
30" x 22" (76cm x 56cm)

shades of gray to a color produces a gradation of different tones.

VALUE AND MOOD

Creating mood is achieved most effectively by controlling and manipulating value. Paintings with lots of darker values will be more somber and quiet, while paintings that use mostly lighter values will be happier, brighter and sometimes less serious. Changing the value of a painting can completely change the way a viewer interprets it.

Smooth Value Transitions
This almost monochromatic painting creates a mood that is subdued yet powerful—almost mysterious. I eliminated the white of the paper to help avoid jumpy value changes. However, the range of light and dark is sufficient to separate the skull from the background using a cast shadow and the evenly toned background. The presence of spirit that once lived with us will not be forgotten.

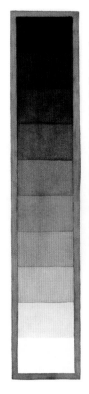

Ten-Point Value Scale
This scale was made by mixing Hooker's Green and Quinacridone Red, then gradually lightening the value with water. Notice that its border appears lighter on the top than it does on the bottom, even though it never changes. This shows how adjacent values can influence the way your eyes perceive value.

Saturation

A highly saturated hue is intense and vivid, while a less saturated hue appears less intense and more muted. Mixing pure hues with other colors, especially their complements, reduces their intensity.

Saturation and value are not always related. A highly saturated yellow, for example, has a high value, but a highly saturated blue has a low value.

When you wish to emphasize a particular color in a composition, juxtapose that color with less intense hues, which will make the first color stand out. Placing the color's complement next to it will also do the trick.

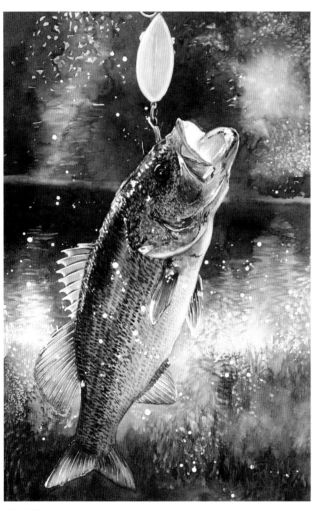

High Intensity
Using intense orange against blue gives sparkle and life to the fish, as if an angler had just caught it. Imagine the same fish as dull green, without any intense complementary color to set it off. It would look lifeless, as though it had been hanging limp on the line for a long time.

My First Catch
Watercolor on Winsor & Newton 140-lb. (300gsm) cold press
21" x 14" (53cm x 36cm)

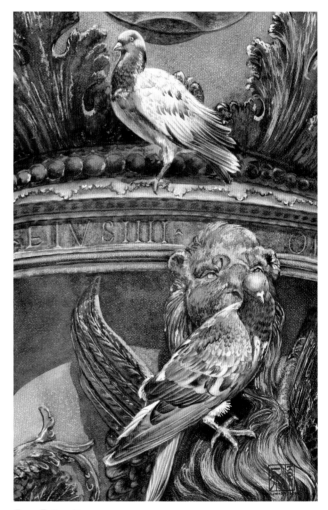

Low Intensity
The two pigeons are not in fact on the same plane, but they seem to be because the colors used to create them and the oxidized bronze fountain have an equally low intensity. With less distinction between the subject and background, the painting takes on a peaceful tone.

Restless Noon
Watercolor on Winsor & Newton 140-lb. (300gsm) cold press
21" x 14" (53cm x 36cm)

Contrast

Contrasts in color quality and value allow you to create clear distinctions between objects and areas in your paintings, such as the subject and the background.

Generally, the viewer's eye is attracted to high-contrast images, which tend to have sharper, bolder elements. Low-contrast images are more subtle. However, each type of contrast has its place and purpose in painting.

CHOOSING LOW CONTRAST

Low contrast is ideal when your goal is a quieter, highly harmonious composition. Using mostly tints of colors and lightly shaded images, a low-contrast composition will not have dramatic value transitions that make certain areas stand out. When there is less distinction between the main subject and its surroundings, the picture seems calmer and more serene to the viewer.

Bear in mind when working with an *analogous* color scheme—colors that are next to each other on the color wheel—it may not have much color or temperature contrast, but it may well have a lot of value contrast. The same goes for a monochromatic color scheme. However, if you narrow the range of values used, both make good options for low-contrast paintings.

CHOOSING HIGH CONTRAST

Using high contrast is a good way to emphasize specific elements of the subject and create a dramatic visual impact. Even a small, pale element will garner attention when it's surrounded by colors with darker values, and vice versa. Exaggerating light and dark contrast can turn an ordinary painting into an extraordinary one.

The juxtaposition of highly saturated, complementary colors produces strikingly powerful color interactions with high contrast.

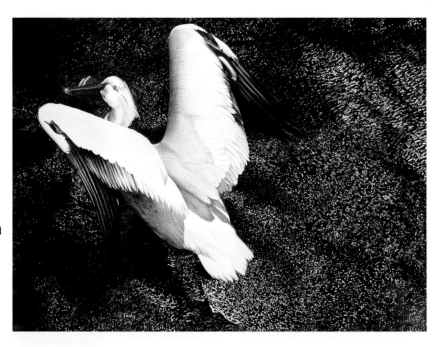

High Value Contrast
The value difference between this subject and background is significant, creating a sharp distinction. The lightest values—achieved by saving the white of the paper—grab instant attention, capturing and directing the eye to the pelican taking off from the water.

Ready for Soaring
Watercolor on Arches 140-lb. (300gsm) cold press
21" x 29" (53cm x 74cm)

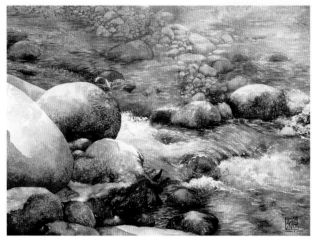

Low Value Contrast
High dilution creates low value contrast, even with normally high-contrast, complementary colors. In fact, it's possible to create a low-contrast painting using the entire spectrum of hues on your palette. To achieve low value contrast with a broad range of colors, dilute your pigments before applying them to create tints. This particular low-contrast painting may not jump out at you, but it grows on you for a lifetime of pleasant viewing.

Stream II
Watercolor on Arches 140-lb. (300gsm) cold press
21" x 29" (53cm x 74cm)

Composition

The arrangement of visual elements such as lines, shapes, values and colors is what makes your painting stimulating and unforgettable to the viewer. There are no strict rules or formulas to follow for the perfect composition, but some guidelines do exist to give you ideas to consider as you compose and complete a painting. They are meant to help you, not limit you.

Understanding the guidelines of composition can be especially helpful when problems arise during the painting process. However, no magic formulas or rules can replace your intuition to make a painting's composition exciting or complete. To make an interesting composition that stands out from the rest, balance these guidelines with your own instincts rather than strictly adhering to rules. As always, experiment to discover what works for you as an individual.

FORMAT

First, you must choose a *format* (surface orientation) for your particular painting subject. Landscape (horizontal) and portrait (vertical) formats are popular options, but you might consider oblong, square or unusual shapes such as ovals or diamonds to draw attention to your work, if they suit your subject.

EYE MOVEMENT

As you plan your composition, think of how your eyes moved around your reference photo or sketch. Where did your eyes linger? What led them there? Various elements will invite the viewer's eye to linger for a while in certain spots to appreciate details, colors or other features as it travels around, but the most effective compositions encourage the eye to visit all parts of the painting.

Unless you have a good reason for doing so, avoid placing your main subject in the middle of the composition. That will shorten your viewer's attention span and give the painting a static feeling. Instead, place your subject off center, possibly even allowing it to extend beyond the paper in places. You can also encourage eye movement by repeating elements throughout the painting, creating directional lines, or enlarging the main subject.

CENTER OF INTEREST

In any painting, you will want to strongly emphasize one spot to grab the viewer's attention. That part of the painting becomes the *center of interest* (or *focal point*). The other elements you choose for the design should support the focal point, not overpower it. Supporting compositional elements can have varying sizes, colors, values, and so on to stimulate interest, but all choices regarding these elements should have the goal of leading the eye back to the center of interest.

REPETITION AND RHYTHM

To create interesting, exciting movement in a composition, you can repeat shapes, lines, colors or values. Repeating compositional elements not only unifies the painting, but also makes the rhythmical movement of a painting more pronounced and effective. A variety of similar elements will create a harmonious, balanced design.

BALANCE

Evaluating a composition for balance is usually based more on intuition than exact science. Trust your judgment. If the arrangement of elements

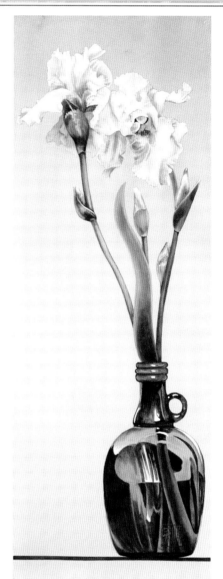

A Format That Fits
This long format not only suits the subject perfectly, it eliminates the need to fill a large, empty background.

Green Vase
Watercolor on Arches 140-lb. (300gsm) cold press
30" x 15" (76cm x 38cm)

in a composition makes you feel comfortable rather than uneasy, the composition is probably well balanced. Study the work of artists you respect, training your eye to spot the relationships they've established between elements so that you can sharpen your ability to judge for good balance.

LINE
Horizontal, vertical and diagonal lines all contribute to the mood and movement of a painting. Horizontal lines give the impression of calm, tranquility and spaciousness. Vertical lines tend to suggest height and grandeur. Diagonals have a dynamic, lively effect on a composition: they convey a sense of movement, energy and, at times, tension. Generally, curved lines create a sense of flow that can be either gentle or energetic.

Lines can also direct attention toward the main subject, or contribute to the organization of the painting by dividing it into sections.

SUBJECT PLACEMENT
Whatever you paint, whether still life or landscape, compose the elements around the main subject. As you begin creating a composition, isolate the subject from the background. Position your subject within the format in a way that emphasizes the subject but allows the background shapes to be interesting.

Every artist has personal preferences when it comes to composition and positioning subjects. I tend to like the subject to be close up, to fill my paper as much as possible. I usually look for interesting *negative space*—the areas around a concrete (or *positive*) shape—that will stimulate eye movement.

Advantages of Filling the Paper With Your Subject

- The center of interest will stand out better without distraction from the background.
- A feeling of freedom is created as the subject spreads out, perhaps even extending beyond the edges of the paper.
- A static feeling is avoided when the focal point is not surrounded by a solid, stifling background.
- You can spend more time working on interesting elements of the subject rather than laboring over the background.
- This approach tends to result in simple yet bold and memorable compositions.

Repetition Encourages Eye Movement
The same saturated hues are repeated several times within the center of interest, while curved lines are repeated in the water. Other areas are deemphasized with less intense, lighter colors and simpler lines.

Journey
Watercolor on Arches 300-lb. (640gsm) cold press
22" x 30" (56cm x 76cm)

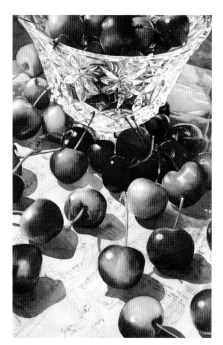

A Setup With Spontaneity

Cropping off the top of the cherry-filled bowl opens up the upper space of the painting as well as the areas surrounding the bowl. Placing cherries naturally and randomly on the black-and-white newsprint creates maximum contrast. This composition encourages the viewer's eye to wander freely, even in and out of the painting.

Bing Cherries
Watercolor on Arches 200-lb. (425gsm) cold press
39" x 25" (99cm x 64cm)

Take the Eye for a Ride

How do you tear the viewer's eye away from this bright bloom long enough to explore the rest of the painting? Let a strong cast shadow in a complementary color point the way. The blue-violet shadow wraps around the flower and moves downward. The eye follows it, then moves on to the detailed lace before returning to the flower.

Yellow Daisy
Watercolor on Arches 300-lb. (640gsm) cold press
30" x 22" (76cm x 56cm)

Perspective

Perspective in painting involves the challenge of creating the illusion of three-dimensional space on your two-dimensional paper. Perspective applies not only to street scenes and buildings but to subjects as simple as a bowl sitting on a table. When you find yourself feeling uneasy about your image because something appears to be not quite right with respect to angle, position or size, a basic understanding of the principles of perspective may help you solve the problem, rescuing you and your painting.

Below are definitions of some fundamental terms and descriptions of the various types of perspective. Mastering accurate perspective drawing will give you the freedom to concentrate on other elements of your representational works of art.

VANTAGE POINT

The *vantage point* refers to the position of the viewer in relation to the subject. In most compositions, the vantage point is at normal eye level relative to the horizon. An unusual vantage point can create a more dramatic painting. Consider the exciting possibilities of looking at your subject from above (a *bird's-eye view*) or below (a *worm's-eye view*). The vantage point you choose for your composition will determine which type of perspective you should use. Both will have a significant impact on the way the viewer perceives your subject.

VANISHING POINT

A *vanishing point* is a single point in the distance where two or more parallel lines appear to converge. The point of convergence usually occurs somewhere along the horizon line, at the viewer's eye level. It may exist

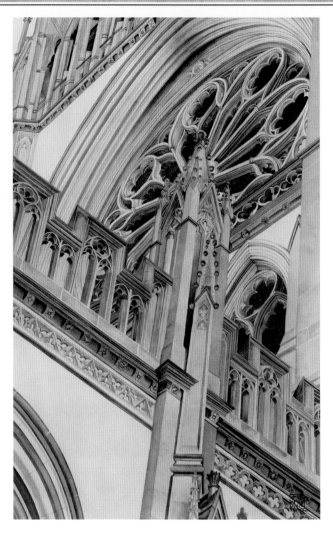

Dramatic Three-Point
The perspective is apparent here even when we see only part of the building. The vanishing points are located off the picture plane: two near the midlines off the left and top, and a third off the lower right side. Additional drama is created where the tip of the tower meets the window, linking the foreground and background.

Divine Lines
Watercolor on Arches 200-lb. (425gsm) cold press 39" x 25" (99cm x 64cm)

either within or beyond the frame of the composition. There may be more than one vanishing point in a given composition, depending on the vantage point and the type of perspective that suits the scene.

ONE-POINT PERSPECTIVE

One-point perspective involves a single vanishing point. Imagine a long railroad track that vanishes into the distance at the horizon. Horizontal lines—by definition—lie parallel to the horizon, but seen in perspective, those that recede into the distance (in this case, the rails) appear to run diagonally as they converge toward

a vanishing point. In one-point perspective, only the horizontal lines that also run parallel to the *picture plane* (the actual surface of the painting) will appear parallel to the horizon. These lines (think of the railroad ties) will appear shorter as they recede into the distance. Vertical lines (imagine a row of telephone poles alongside the railroad track) are perpendicular to the horizon. The farther vertical lines are from the viewer, the shorter they will appear when seen in perspective.

TWO-POINT PERSPECTIVE

Two-point perspective, as the name suggests, has two vanishing points.

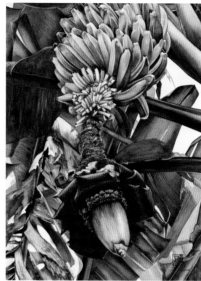

Imagine that you are looking at the corner of a house, able to see two exterior walls. As with one-point perspective, the vertical lines of the walls are perpendicular to the horizon, but in two-point perspective the receding horizontal lines appear to run diagonally in two different directions, toward two separate vanishing points (one at the left of the house, and one at the right). None of the house's horizontal lines run parallel either to the horizon or to the picture plane.

THREE-POINT PERSPECTIVE

Three-point perspective may be required when the viewer's van-tage point in relation to the subject is either high above or far below normal eye level, or when a composition's picture plane is not parallel to any of the subject's three axes. Imagine looking up from the ground at the corner of a skyscraper (the worm's-eye view). The horizontal lines of the two sides of the building appear to recede toward their respective vanishing points (as did those of the house in two-point perspective). In addition, the vertical lines also appear to recede, toward a third vanishing point somewhere in the sky. If you were on top of the building looking down toward the street (the bird's-eye view), the vertical lines would appear to converge at a point somewhere below the ground.

AERIAL PERSPECTIVE

Aerial (or *atmospheric*) *perspective* involves simulating the visual distortions that result from moisture or particles in the atmosphere to achieve a greater sense of depth in a painting. Objects seen at a distance appear less distinct, less detailed, lighter in value and cooler in color than they do when viewed close up. By reproducing these natural effects in a painting, the artist can add to the illusion of depth.

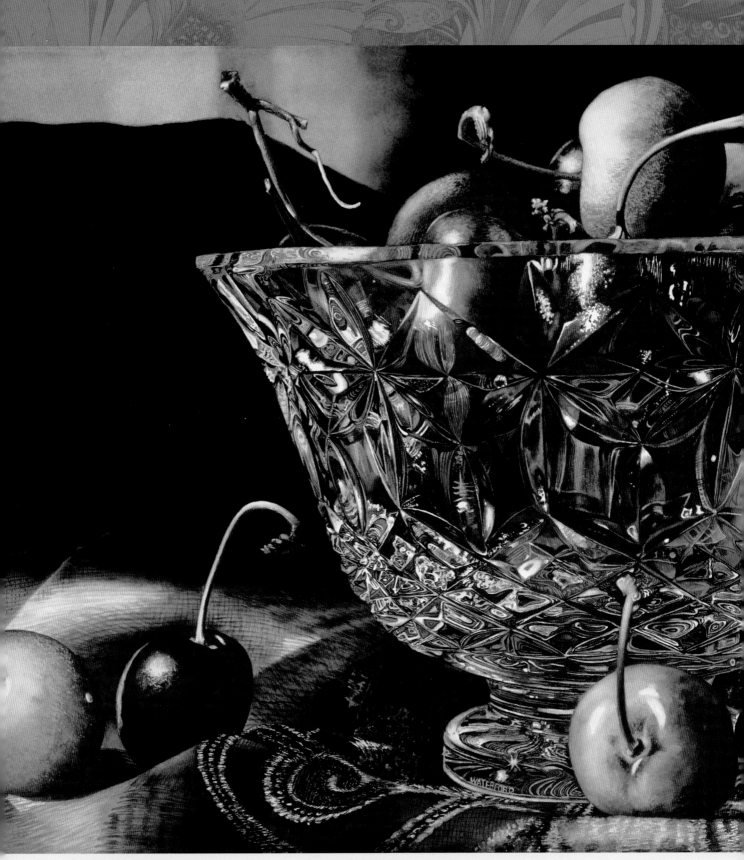

Waterford and Cherries
Watercolor on Arches 300-lb. (640gsm) cold press
22" x 30" (56cm x 76cm)

Preparing to Paint:
Choices and Techniques

When I visit museums, galleries or art shows, some paintings hold my attention as I view them in awe and admiration. Representational art by highly skilled artists has always captured my interest. I sense the artists' deep emotion and feel the passion in their paintings. The results of their devotion, time and attention do not happen just by accident or because they can mimic similar work by others. They consider what they want to say about a subject, then find the best way to communicate it by making appropriate choices and applying good technique.

I recall, when I was young, being disappointed that I did not have that ability. These days, I am reliving my childhood experiences through my eight-year-old nephew, Hae Seong. He constantly compares his drawings to mine and laments that his don't resemble what he's drawing. It worries me to think he might give up drawing because his work falls short of his ideal.

One day I took him to a few art museums. He admired the representational paintings he saw. He wondered how a person could paint so realistically. He was less impressed with nonrepresentational works. He thought the paintings were just scribbles and doodling, not art. He told me that he could make a painting that would be as good as many of those. When we returned home, I set up an easel with canvas and oil paints for him and he set to work—not on realistic paintings, but on scribbles and doodles. How ironic that the paintings he *didn't* like inspired him to paint! He was very amused by the fact that I liked his painting, but he still didn't.

In this chapter, you will learn a few techniques to help you create more realistic paintings, and well as get advice on choosing subjects and deciding how to approach painting them. Open your mind wide and incorporate different ideas into your artwork. From time to time, I enjoy incorporating abstract or nonobjective elements into my realistic paintings to create visual interest. My nephew's "doodle" painting hangs where I can look at it often, to learn from it and be inspired.

Finding a Subject

What should I paint? The best answer to that question is everything and anything, abstract or concrete, ideas from nature or from manmade objects. Paint what will express your desire and passion. It is possible to paint anything when you put your mind to it. Expressing yourself in art doesn't mean that your subject has to be recognizable to you or to viewers. What is most important is that you do what you want to do.

Paint something to both grab your viewer's attention and to express what you want to express. Some will want to paint a beautiful sunset; others will not. A run-down barn gets one person's attention, but not another's. Bare branches of a tree inspire some artists, but not all. Whatever sparks something inside you should become the subject of your next painting.

Something as simple as an odd color or shape may offer inspiration.

Countless things can inspire you. Look around and you may see a portrait, a still life or an abstract that could become the subject of a painting. Making an individual subject special is your job as the artist. Grab your brush and paint!

COLLECTING PHOTOS

Whenever and wherever possible, take a camera with you. Then, when you see beautiful buildings, scenery or even a little nook that you like, take photos. If possible, take some close-up photos in addition to panoramic views so you will have details of a scene's elements. Over time, you will create your own library of reference material. When you can't take a photo, sketch a site or a sight, so the details will be easier to recall as you paint.

Whether on a trip or walking through a local park, take reference photos with good compositions in mind. Take a photo from one vantage point, then walk to the other side of the setting and shoot back toward the place where you started. Compare the photos and you will be surprised at how different the same scene can look from opposite sides!

Why do images shot by professionals look so great? The secret is that a designer reviewed dozens—perhaps hundreds—of photos before selecting a few flawless-looking ones for publication. However, you don't need to be a great photographer to create great source materials for your paintings. Use your skills as a great artist to create a wonderful work of art using even the flat, out-of-focus pictures you took on a trip last year.

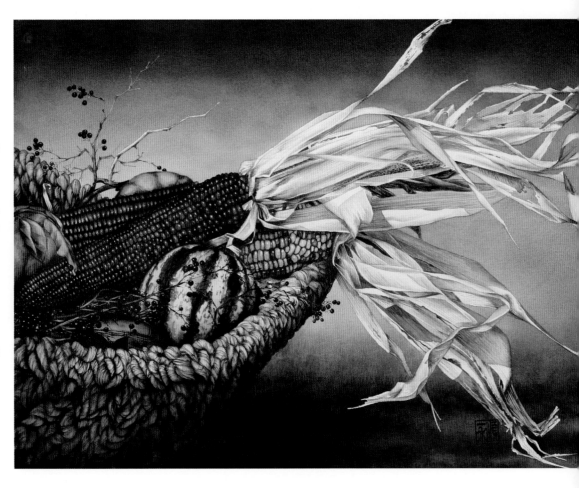

Seasonal Left-overs Make Great Subjects
Left-over dried corn and pumpkins are good subjects for paintings. Save the decorations you see around the house every autumn and paint the beautiful colors of the gourds and the corn with its dried husks before you throw these items away.

Harvest II
Watercolor and India ink on Arches 300-lb. (640gsm) cold press
22" x 30" (56cm x 76cm)

Using Reference Photos Wisely

You may have boxes of snapshots. Go through the photos with an eye for their potential. Open your mind to look for one you can turn into a beautiful painting. Rarely does an individual photo display elements perfectly arranged in an attractive composition. The solution? Combine elements from two or three different photos to piece together an exciting composition. As you look for elements that will work well together, make sure that the light source is in the same place in all the photos.

I file my photos by subject or name to save time later when I am hunting for something specific. Use any file system that will work for you.

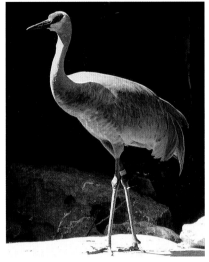

Reference Photos

Combine Photos With Imagination
You could use one of the photos for the background, or invent one that feels right for your painting. Here, I created an airy, subtle lotus field with almost no contrast—instead of my original idea of a dark, woody, highly contrasting background—to emphasize the elegance of the cranes.

Know the Source of Your Sources

Use your own reference photos for your paintings as often as possible. Someone somewhere owns the copyright to all published materials. If you want to use copyrighted material, you must have permission from the owner, though the owner may specifically grant free use. As you obtain permission, remember to inquire about how the owner wants you to acknowledge the source of the reference.

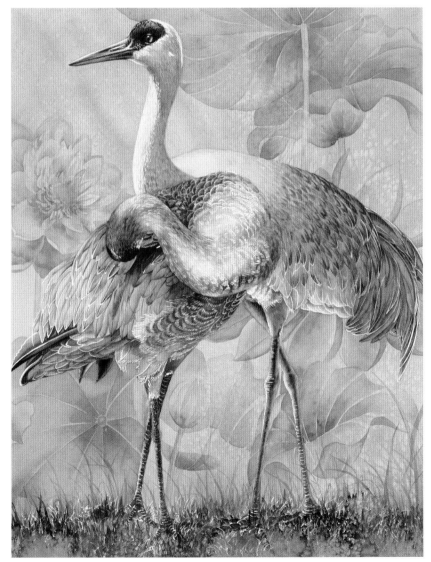

Sandhill Cranes
Watercolor on Arches 140-lb. (300gsm) cold press
29" x 21" (74cm x 53cm)

Choosing the Most Effective Light

Magic happens in a painting when varying intensities of light play upon objects. Light brings out drama from an ordinary object, making it extraordinary. Strong direct light, for instance, creates cast shadows with high contrast that in a composition can help guide the eye, describe the scene and set the mood. The play of light can give you new ideas or different approaches to the same subjects, adding drama while creating exciting compositions and designs.

It is possible to take good reference photos any time of the day or night. The light on a sunny day will produce a different mood from that of a rainy day. In fact, lighting can change the feeling of a subject dramatically, whether the effects are subtle or bold.

MORNING LIGHT

Early morning light, from about 7 A.M. to 10 A.M. in the summertime, reveals very crisp, clean colors. Lighting during this time of day will capture the subject's local color and soft shadows beautifully, creating less contrast and softer edges. The elongated shadows present during this time create a graceful rhythm for the subject that you can play with to create a more interesting composition.

Refreshing calmness always enters my mind from the early dawn throughout the morning. At the same time, the light accentuates the energy of life I feel at the beginning of the day. Consider the feelings you experience at certain times of day, and that may help you choose the best lighting situation for the mood you want to convey in your painting.

DIRECT DAYLIGHT

On sunny days at noon, sunlight showers down on the top of subjects. Because the light falls from above, the shadows are short, with sharp contrast. This lighting situation produces images with few details to play with, but gives you intense cast shadows that can become important compositional elements.

Note that automatic camera settings tend to lose lighter local colors. For future painting reference, make notes describing the lighter colors and your feelings about the subject. These notes will provide invaluable reminders as you turn your reference photos into works of art.

EVENING LIGHT

Try capturing the light right before sunset, when the sunlight is still strong and the cast shadows are long but not sharp. Feelings of warmth and coziness naturally occur at dusk and in the early evening, when the light casts a yellowish or reddish glow.

OVERCAST LIGHT

To capture the details of a subject, an overcast day is ideal. There are neither harsh cast shadows nor highlights, just undistorted subjects firmly ensconced in their surroundings. It is the perfect time to capture subjects in a gentle, quiet moment.

SIDE LIGHT

Light from the side is the most common in a still-life setup or in nature. On a sunny day, light from various angles on one side of a subject creates wonderful shadows on the opposite side. These shadows define

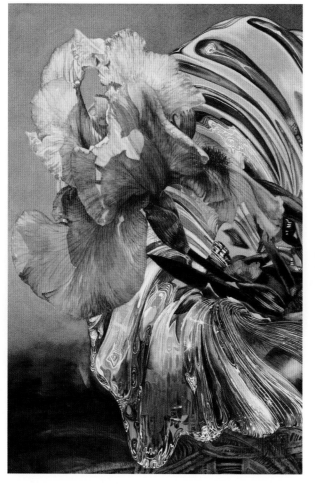

Backlit Brilliance
The bright backlight cuts sharply through the iris petals and glass. The thin, fresh flower and translucent glass make the painting seem light-hearted and cheerful, just like early springtime.

Golden Iris and Glass
Watercolor on Arches 140-lb. (300gsm) cold press
22" x 15" (56cm x 38cm)

the contours of a subject gracefully. Less dramatic lighting enables you to reproduce the subject in a more accurate and subtle manner.

BACKLIGHT

In a natural light setting, backlit subjects can be the most interesting and versatile for experimentation. Light coming from behind an opaque object can make the edges of the object glow brighter than its center, giving the subject strong, dramatic impact. On the other hand, backlight penetrating through translucent objects can give different personalities to thin materials and glass. Subjects with varying degrees of opacity and translucence can appear to glow from within.

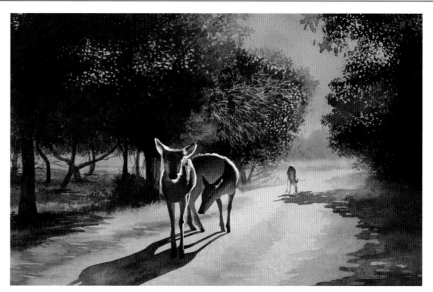

Backlit Warmth
It is about time to come home after a long day. The yellowish low light coming from behind the subject, coupled with the long shadows of the deer, signals early evening. The warmth that results fulfills our need for comfort and rest at the end of the day.

The End of Day
Watercolor on Winsor & Newton 140-lb. (300gsm) cold press
14" x 21" (36cm x 53cm)

Sidelit Shadows
Setting up a scene beside a sunny window creates obvious side light. Because a wall blocks other light sources here, the concentrated window light creates strong cast shadows on the subject, just like an artificial light would in a studio. Playing with light is a fun part of playing with a composition.

Shadow Play
Watercolor on Arches 300-lb. (640gsm) cold press
22" x 30" (56cm x 76cm)
Collection of Peter and Alice Haslam

Consider What the Flash Will Do to Your Photo

When you take a snapshot point-blank in a dark area, the automatic flash pops. It is very easy to record the general features of the subject in a flash photo. However, using the flash as your light source creates a flat image with few shadows and little contrast, and therefore no depth. So, when you want to record a specific image on film, think about how the flash will affect the values in your subject.

Cropping for the Best Composition

Often, a photo may look poorly composed when you view the image as a whole—yet, you may spot very nice, high-quality elements within the photo. Use a cropping tool to find the best possible composition within an otherwise unpromising photo. At times, you can crop to make two or three good compositions out of a single photo!

To make your cropping tool, use white or off-white mat board to make two L-shaped pieces at least 7 inches (18cm) long on each side and 2 inches (5cm) wide. Increase or decrease the size of the opening to see what works for a good composition. Avoid colored mat board for this tool, as the color may distort the overall feeling and perceived color balance of the cropped composition.

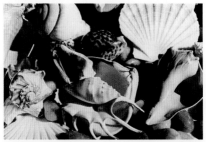

Reference Photo
The original photo of seashells is in sharp focus, but too busy for what I want to show in a painting.

Cropped Composition
I picked the shell I wanted to paint and cropped out most of the rest. I want to focus attention exclusively on this shell and the yellow stone beside it.

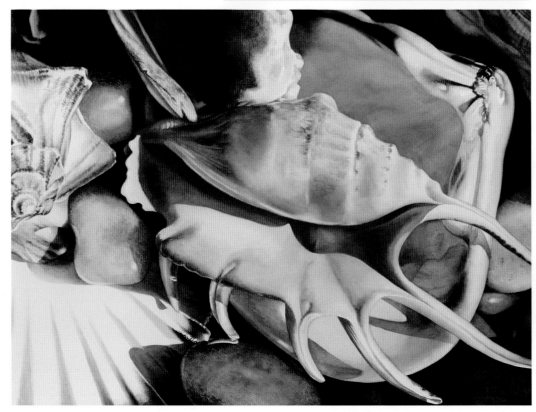

Focusing Attention
This kind of shell, with its mellow peaches-and-cream color and smooth surface, always captivates me. The surrounding partial shells and stone make a wonderfully harmonious backdrop for the main attraction.

Sea Shells and Yellow Gravel
Watercolor on Arches 300-lb. (640gsm) cold press
22" x 30" (56cm x 76cm)

Drawing: Tight or Loose?

To paint a highly realistic painting, a detailed drawing is not only helpful, it is a necessity. It will save time and prevent headaches later in the process. You can discover whether the composition works, how the eye moves around it, and if any element is missing or looks odd. In contrast, for landscape or loose paintings, detailed drawings are not needed. To help you feel comfortable and confident, it would be sufficient to draw just the contours of the larger elements to suggest a composition.

Because one of the biggest challenges for the watercolorist is determining where to save the white of the paper for highlights, a tight drawing can be very helpful. It can show you where to leave lights so you won't have to resort to using white pigment or a lot of masking fluid. Though masking fluid can be useful for saving highlights, it is not practical to use all the time. Instead, carefully delineate the light areas from the darker areas on your drawing, which becomes a guide for where to apply the intended colors and where to keep the dark pigments out.

It is possible to freehand drawings without the help of mechanical tools. For complex drawings, however, you can use the grid system, or use a projector to enlarge an image so you can quickly trace an outline on the paper. However, don't rely on these tools to create perfect drawings. In the end, your painting skills will improve the most when you learn to draw well without any tools.

Tight Drawing

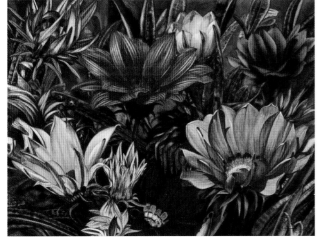

A Detailed Drawing Helps You Protect Light Areas
A carefully planned, detailed drawing makes it possible to control the placement of every petal and leaf. It will help you save areas of plain paper for the yellow and orange flowers from the dark pigments that would otherwise ruin these light blooms.

Summer Daisy
Watercolor on Arches 140-lb. (300gsm) cold press
21" x 29" (53cm x 74cm)

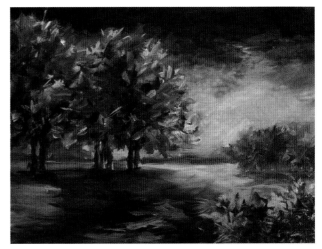

Loose Drawing

Loose Lines Act as a Reminder
When painting the open field of a landscape or other types of unstructured elements, a tight drawing is not necessary and can actually interfere with the painting. A few scribbled lines indicating main elements may be more than enough to set up the scene.

Weatherford
Acrylic on Winsor & Newton 140-lb. (300gsm) cold press
15" x 22" (38cm x 56cm)

Layering describes the process of overlapping colors: applying new paint over an existing layer. Layering using simple techniques such as washing, glazing, wet-on-wet application or drybrushing will increase a painting's complexity. Layering provides a way to add or change colors, deepen values or create textures in a painting that would otherwise appear flat and simple. When layering, apply paint on wet paper (*wet-on-wet*) for softer effects, and paint on dry paper (*wet-on-dry*) for precise control and definition.

THE WASH

A *wash* is the application of diluted pigment to a surface. You can apply a wash in two ways. The first is on a wet surface, which gives you time to apply the paint while sipping coffee with your other hand. The second is on a dry surface, during which you have to move your brush as fast as possible to avoid unwanted brush marks or unevenness.

By applying washes early in the painting process, you have the freedom to move your brush back and forth across the surface without hesitating. Applying washes with a hake brush will allow you to cover the surface of the paper quickly. You can add wash layers as many times as you wish to achieve the desired color intensity at the beginning of the painting. You can change the colors for each layer if you wish to create variegated or gradated effects, or use a single color for every wash layer. An overall wash applied at the beginning of the painting can set the mood (pale yellow for warmth, for example, or pale blue for quiet). Then, before rendering the subject, use another wash to create the perfect even or gradated background. This is the easiest, most effective way to achieve the desired background without disturbing the subject by trying to carefully paint around it later.

Here are two thoughts to remember when washing. First, if you notice things like a little unevenness in the intensity, or even a stray hair on the wet surface, do not try to correct it immediately. Just let it dry. There is always a chance to fix the problem after the surface is completely dry. Otherwise, you risk creating unwanted blossoms or damaging the paper while it is wet and soft; such damage can create dark spots. Second, remember that if you plan to use the white of the paper for highlights in your painting, use masking fluid to save it. Otherwise, you will lose the white during the washing process.

WET-INTO-WET AND MINGLING

The term *wet-into-wet* means applying paint to a wet surface. Rather than brushing on the dry surface, drop the colors on a wet part of the paper. The wet area may be anything from little flower petals to a large empty background to the entire surface. In addition, you can apply a new color near the edge of a previously dropped color to *mingle* the two without creating a hard edge. Applying paint wet-into-wet also presents the opportunity for looser expression and freer form if you use feathered brushstrokes.

Because the water on the paper further dilutes the pigment, you may need to apply several layers if you wish to produce stronger color saturation or a darker value. For the final touches, use controlled brushstrokes

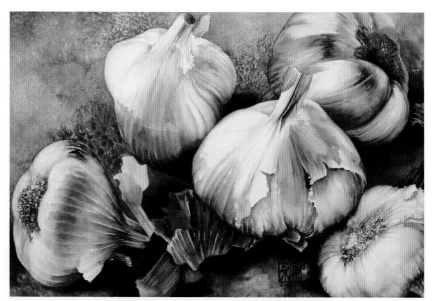

Beginning With Wet–into–Wet
This painting was made with alternating wet-into-wet and dry-brush techniques. I dropped several colors on the wet surface where the garlic would be, then moved the paint around the background loosely. After it dried, I applied the several dense colors around the garlic to define their shapes. I drybrushed as a final touch to finish the roots and sharpen the lines of the skin.

Garlics
Watercolor on Winsor & Newton 140-lb. (300gsm) cold press
15" x 22" (38cm x 56cm)

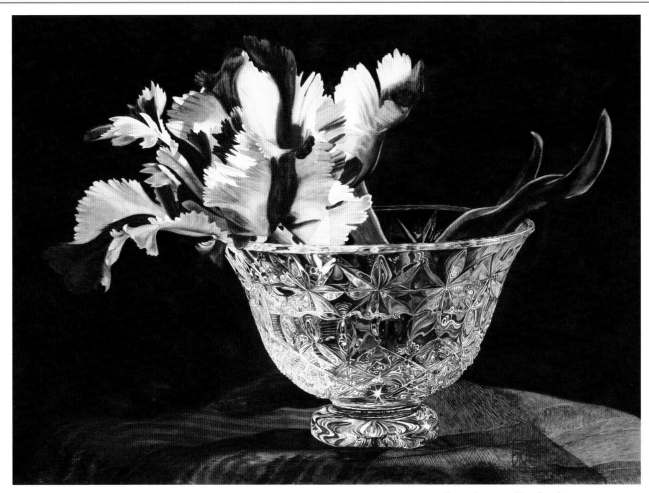

to add details as needed—but only after the surface has dried, of course!

GLAZING

Glazing is the application of a thin layer of paint on existing layers of color. It is a simple technique for building the necessary values of light and dark within a painting, or creating or adjusting colors without physically mixing paints. Most of the demonstrations in this book deal with layering glazes to create realistic paintings. Glazing allows a smooth transition between light and dark values to render any subject in three-dimensional form.

You can glaze using pale, highly diluted paint or dark, less diluted paint—or premixed colors for small areas—to build up to the desired effect. Usually, it is better to start with lighter values and thinned paints, which allow you to deliberately build and adjust colors in a slow, controlled manner. Try to use one hue at a time, then switch to a different color for the next step. It is most important when glazing to wait for the previously applied layer to dry before applying the subsequent glaze. Glazes usually dry quickly, so you can save time by looking for dry elements in the painting to reglaze. The elements eventually unite to become a complete painting. Of course, this simple technique requires some degree of control, especially when you try to cover larger areas.

Layering on a Dry Surface
Layering paint on a dry surface usually produces a hard edge, enabling you to create a precise shape with your brushstrokes. In this painting, the flower and cut crystal are clearly defined, as are all the other elements in the composition. This realistic representation is crisp and sharp overall.

Parrot Tulip and Crystal
Watercolor on Arches 140-lb. (300gsm) cold press
22" x 30" (56cm x 76cm)

The advantage of glazing is that luminous, clean color is easier to achieve while avoiding big mistakes or effects that depart from your plan. In other words, you gain control. After each step of the glazing process, step back to evaluate the painting before beginning the next step. Glazing produces a whole range of colors that you won't have to mix on the palette. With glazing, you can achieve precise values in small and large areas of a painting. Does this seem like tedious and hard work? Yes, but it will be worth it after you see the results in your finished painting.

TWO WAYS TO GLAZE

There are two common ways of glazing. One is on a dry surface. Apply paint to a dry area, blending and feathering out to lighter areas with a clean, damp brush.

The other way is to wet the part of the surface you want to glaze with clean water, and then apply pigment on the wet surface, blending and feathering as needed with a clean, damp brush. After any glaze layer made with concentrated paint, glaze the next color on a dry surface and move your brush gently to minimize lifting of the previous layer of color.

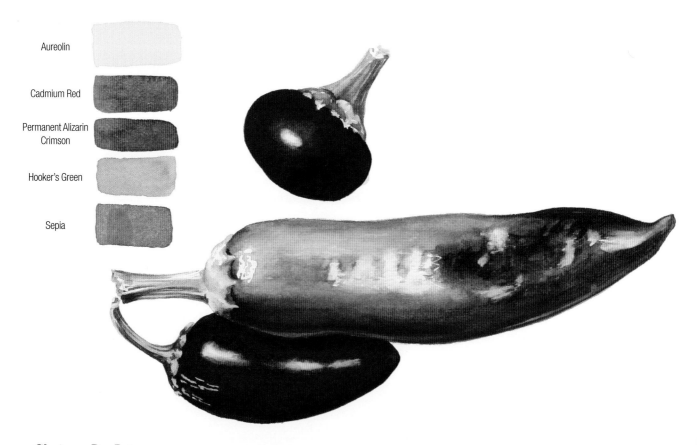

Aureolin

Cadmium Red

Permanent Alizarin Crimson

Hooker's Green

Sepia

Glazing on Dry Paper

I painted these peppers using several colors, glazing each color separately on dry paper after applying masking fluid to save the highlights. It was easy to control the differences in the red shades by glazing.

1 Aureolin: glazed lightly for the two outer peppers and heavily for the center pepper, including the stems

2 Cadmium Red: glazed on the center pepper, creating orange

3 Permanent Alizarin Crimson: glazed on the end and bottom of the largest pepper and on the two smaller peppers

4 Hooker's Green: glazed on all stems

5 Sepia: glazed on the peppers and stems to render shadows and depth

I finalized the darkest parts of the peppers and stems by applying a dark mixture of Permanent Alizarin Crimson, Sepia and Hooker's Green. After removing the masking fluid, I toned down some of the highlights with their surrounding colors.

Using Masking Fluid

Portraying cut crystal looks complicated and difficult at first glance. Creating a painting that has such detail requires much patience and time. However, when you start to break down the large shapes and define each element with light and dark, eventually you will define the overall shape and convey the transparency of the glass. In order to show the sparkle of glass, preserve the white of the paper for the highlights using masking fluid. The surrounding colors within the composition define the shadow and color of the glass.

Materials

Arches 300-lb. (640gsm) cold press • masking fluid • nos. 4, 8 and 12 rounds • 3½-inch (89mm) hake • rubber cement pickup • old brush with plastic handle cut at a slant

Watercolors

Winsor & Newton: Aureolin • Hooker's Green • Permanent Alizarin Crimson • Permanent Magenta • Prussian Blue

Reference Photo

Drawing
Define the details of the cut crystal and the shape of the glass. This is a time-consuming process but it will be very helpful in later steps. Find the large patterns first, working toward the smaller patterns.

1 Apply Masking Fluid and the First Wash
Use the tip of a plastic brush handle (cut at a slant) to apply masking fluid on the highlight of the glass. After it dries, wet the surface of the paper. Next, using a 3½-inch (89mm) hake, apply a very light wash of Prussian Blue on the glass for the first of many layers of different colors. This light wash will become the light to midtone of the glass.

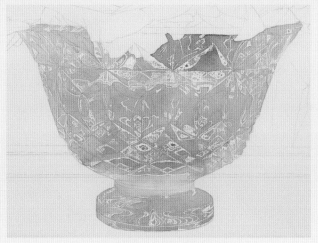

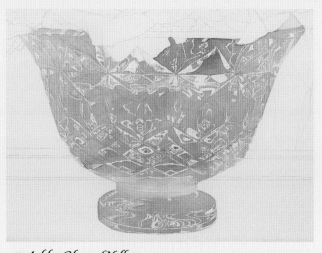

2 Lightly Glaze the Glass Section by Section

Squeeze Prussian Blue on your palette a few inches (8 or 9cm) away from Permanent Magenta. Starting with a uniform mixture of the two, apply it to part of the glass using a no. 12 round. As you move to other parts of the glass, adjust the color by varying the amount of each hue in the mixture. The masking fluid allows you to apply the colors freely and quickly. Let the paint dry.

3 Add a Glaze of Yellow

Apply diluted Aureolin with a no. 12 round. The bluish and purplish colors of the glass will take on a mellow, earthy appearance after the yellow application.

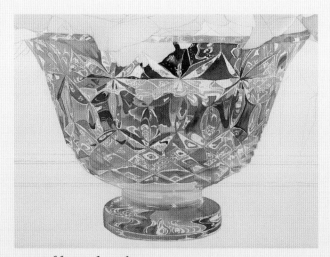

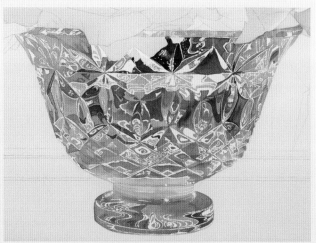

4 Add a Darker Glaze

Using a no. 8 round, glaze Prussian Blue, Aureolin and Hooker's Green section by section on the glass, alternating the colors. It remains easy to apply color without worrying about saving the white of the paper.

5 Remove the Masking

Remove the dried masking with a rubber cement pickup. Run a dry palm across the area to feel for any remaining sticky spots and rub off the rest. Note that at this point, the unmasked whites stand out too much.

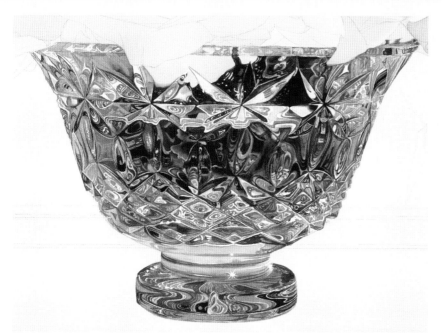

6 Finalize the Details

Using the colors from previous steps, mixing in Permanent Alizarin Crimson as needed to deepen the color, finish the glass with a no. 4 round. The colors reflected by the crystal change, depending upon the colors that surround it. To render the reflections of stems and leaves on the glass, concentrate on darkening the center areas of the glass with dark bluish green. Create gradation within some areas of the crystal, especially in the center, to show the refraction of light. Tame most of the unmasked white lines using their surrounding colors, leaving only flickering white highlights. Tone down some by glazing and others by brush drawing lines that follow the cuts in the glass.

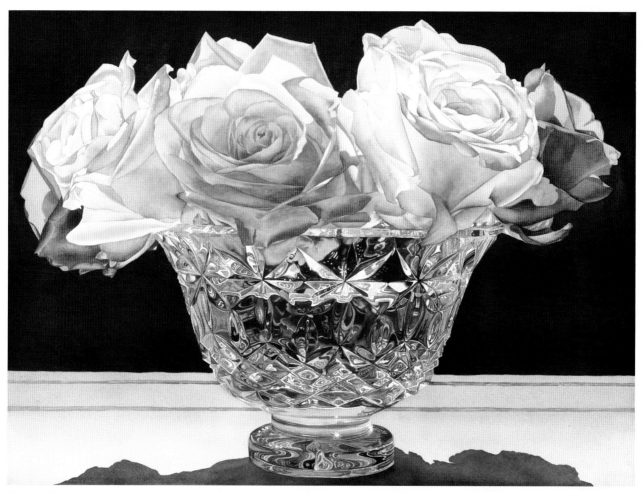

Roses and Crystal
Watercolor on Arches 300-lb. (640gsm) cold press
22" x 30" (56cm x 76cm)

Loosening Up

Even if you don't usually paint landscapes, you might find yourself so inspired by a natural scene that you can't resist painting it. Now, your challenge is to decide how to best capture the beauty of that moment. When you paint nature, it can be overwhelming to include all the details you recall. Painting every leaf and branch is impossible and, if you tried, the result would be stuffy and busy. Your piece will look great if you just give an impression of the scene using the colors of nature.

Freely giving your impression of the scene doesn't mean that you can create the painting by merely pouring and splashing on your colors. "Controlled spontaneity" may sound like an oxymoron, but even as you freely splash or dab, you need to control where you apply the pigment. You don't want to lose the blue sky to the reddish autumn leaves of a tree. Controlled brushstrokes and definition come at the end of the process. Of course, every artist will paint the same scene differently, using their own style.

Chopped Brushes
Put an old, worn-out brush to good use by making it into a specialized brush. Cut the hairs in alternating lengths. The chopped brush will now be useful for creating uneven textures and lines.

Get Loose With Masking Fluid and Paint
To save the lights, I applied masking to the tree branches, willow leaves and the light water reflection. Left-over masking was randomly splashed on to give the impression of light coming through the trees. Then, I splashed and poured on colors and loosened them up with a spray bottle and a clean wet brush. I further loosened them up by applying table salt (see page 51). To strengthen the colors, let them dry and reapply them until they have the intensity you envision.

Chopped Brush in Action
Using a chopped brush, apply colors to intensify specific areas. Instead of defining every tree, just splash on the colors of autumn. To achieve darker values and intense color, apply more concentrated paint on a dried surface.

Moon Bridge and Autumn Garden
Watercolor on Arches 140-lb. (300gsm) cold press
20" x 28" (51cm x 71cm)

Special Effects for Creating Texture

Once you understand and have practiced various glazing and washing techniques, have some fun creating interesting textures using other tools and techniques without brushes. Rendering some textures with a brush is impractical, if not impossible. The creative possibilities are limitless when you open your mind.

Salt

Immediately after applying a wash, while the paper is still damp, sprinkle on some table salt. Brush off the salt after the surface has dried. The salt absorbs the paint, leaving little white starbursts behind. You can even control the direction of the bursts by using a hair dryer or fan. Use this technique to soften a solid-colored background.

Drybrushing

Use a dry-brush technique to create a scratchy, grainy texture. This technique works very well with the heavier textures of cold- and rough-press paper. Using any kind of brush, drag the tip of the brush for the details and small areas. Use the body of the brush for a bolder texture. The brush should be barely damp, loaded with concentrated paint.

Plastic Wrap

Adding rough, irregular texture here and there in your painting can add excitement. Press wrinkled plastic wrap down on the wet area where you want texture. Let it dry completely before removing the wrap. The creases of the plastic will create dark, sharp lines, and textured areas will be light or dark depending on the density of the paint. Define, tame and accentuate the texture with washes and brushwork to harmonize it with the other elements.

Sponging

This technique is easy to control. Wet a natural sea sponge with water and tap it into paint first, then onto the paper to create uneven, scattered dots. You can use several colors, tapping the sponge to apply each one. A wet sponge will mix the color naturally when you tap it onto the paper.

"Salt" Water

In this painting, salt creates the effect of water. The soft, free quality of the salted areas provides a welcome break from the hard, tense areas. After brushing off the salt, add a little dark definition to make the water look like a wave.

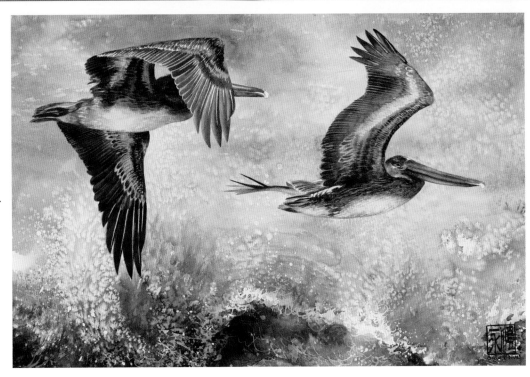

Flying Pelicans
Watercolor on Arches 140-lb. (300gsm) cold press
14" x 21" (36cm x 53cm)

Plastic Wrap for Rocks

Save the fine white lines with masking fluid, then randomly drop several colors onto the paper. Cut pieces of plastic wrap to sizes somewhat larger than the areas they're intended to cover and gently lay them on the wet surface, wrinkling the plastic for small texture and stretching it for larger texture. For sharp texture, let the paint dry completely before removing the plastic. The results look better than brush-painted rocks.

Lazy Afternoon
Watercolor on Arches 300-lb. (640gsm) cold press
22" x 30" (56cm x 76cm)

A Plastic-Wrap Background

I applied yellow on parts of the background first; then, using a wet-into-wet application, red to some areas and blue everywhere else to cover the background completely. Next, I covered the entire background with plastic wrap, stretching it from top to bottom to create the vertical texture. (Do not press it down or the vertical texture will be less effective.) I let it dry for at least six hours.

To enhance the background, I outlined the resulting texture, using a script liner to apply gold powder in an acrylic medium. I glazed on the same background colors to improve some of the texture. The finely detailed face of the lion stands out majestically against the simplified yet interesting backdrop.

Golden Lion
Watercolor on Arches 300-lb. (640gsm) cold press
22" x 30" (56cm x 76cm)

Dry-Brushed Walls

The dry-brush technique lends itself perfectly to portraying these weathered stone walls, making them look old and rough. Drag a barely damp brush loaded with concentrated paint on textured water-color paper (cold press or rough) to create a rough surface. Dry-brush is also an excellent technique for rendering old, dead wood.

Waiting to Be Seated
Watercolor on Arches 140-lb. (300gsm) cold press
14" x 21" (36cm x 53cm)

Sea-Sponge Foliage

Tap natural sea sponges to render the textures of rock, sand or leaves on trees. Using a sponge to create its leaves gave volume to this tree. The light, fine texture that results does not overwhelm the trunk of this strong, lone oak tree, standing in a field and enduring the long summer heat of Texas.

Golden Oak
Watercolor, gouache and gold powder on 140-lb. (300gsm) cold press
14" x 21" (36cm x 53cm)

Sprucing Up Watercolors With Other Mediums

Have you ever wondered how a once grand painting—finished with great satisfaction—becomes weak, perhaps a little boring, as time goes by? I have, and in my studio sits a stack of such paintings waiting to be reborn. Of course, using watercolor to revive an old painting is a little difficult because its characteristic transparency will not hide the old image. The solution is to introduce other water mediums. Tube acrylic, liquid acrylic, gouache, India ink and metallic powder provide great opportunities for rescuing a lifeless painting.

Old Painting
This is my original painting of an orchid named Cattleya gaskelliana alba. When I finished the old painting, I was very excited and proud of the clean, greenish blue glaze of the flower. As time went by, however, my excitement evaporated into thin air and the painting felt boring.

Flip Back

Did you notice that *Weatherford* on page 43 is actually an acrylic work? On occasion, you might want to paint over a piece with tube acrylic, like I did. Once dark values are applied in watercolor, there's little hope to reclaim the light areas, even with hard scrubbing to lift the pigment. Opaque tube acrylic allows you to cover up the darks with lighter color. The obviously free, bold brushwork in this painting expresses more energy, because I no longer needed to apply light and dark colors with exceeding care.

Painting Revived
I wanted to give the painting some sparkle. Fortunately, I liked the composition of the flower, and its lighter color gave me the freedom to decorate with doodles. I drew lines in India ink with a Rapidograph pen. Then, I glazed vibrant watercolors on the flowers. I used gold powder to lighten the overly dark background.

White Orchid Alba
Watercolor, pen and ink and gold powder on
Winsor & Newton 140-lb. (300gsm) cold press
15" x 22" (38cm x 56cm)

Watercolor and Fluid Acrylic

The smooth transition from light to dark in the background was key to making this painting feel warm and rich. The leaves would have been lost in a busy background. To achieve this deep, glowing backdrop, I applied acrylic washes repeatedly. Because fluid acrylic doesn't lift off after it dries, each layer of color enables the creation of a wonderful, dark, smoothly gradated surface.

Sunset Falls Upon
Watercolor and fluid acrylic on Fabriano 300-lb. (640gsm) hot press
22" x 30" (56cm x 76cm)

Adding India Ink

Using a dry-brush technique with India ink, I drew the bark of the tree trunk and some of its dark shaded spots. After the ink dried, I glazed on watercolor to finish. The dark details of the tree's texture are permanent because the India ink is waterproof.

Orchid Haven
Watercolor and India ink on Arches 140-lb. (300gsm) cold press
29" x 21" (74cm x 53cm)

Adding Gouache

Instead of saving the white of the paper for the fur and whiskers, I used white gouache for the final detailing. In addition, the originally distracting dark background of the center was recovered with a mixture of lighter colors.

Young and Restless
Watercolor and gouache on Winsor & Newton 140-lb. (300gsm) cold press
21" x 14" (53cm x 36cm)

Segments of Time
Watercolor on Arches 300-lb. (640gsm) cold press
22" x 30" (56cm x 76cm)

CHAPTER 4

Let's Paint:
Putting Everything Together

Pick any painting in this book and analyze it. Most of the elements I have talked about—value, color, line, texture, and so on—are present in it to a lesser or greater degree. As an artist, I try to emphasize one or two elements in every painting and use the others to support the main theme to give order to the composition. Trying to incorporate all the elements equally creates a chaotic rather than harmonious painting. Each example in this chapter displays multiple elements, but I concentrate on one specific element in each demonstration. As you look at these demonstrations and consider my instructions, always remember that you are the owner of your personal creativity and individuality. It is up to you to apply these ideas in the context of your own work to make them uniquely yours.

Create Texture With Gradating Values

This beautiful dog's name is Noorung-ee, which simply means *yellow dog*. She is gentle and calm, a submissive dog. This demonstration shows the subtle gradation of value you can apply to create smooth as well as furry textures.

Materials

Arches 140-lb. (300gsm) cold press • masking fluid • nos. 4, 6, 8, 10 and 16 rounds • 3½-inch (89mm) and 2½-inch (64mm) hakes • old chopped brush

Watercolors

American Journey: Burnt Sienna

HWC: Sepia

Winsor & Newton: Aureolin • Indigo • Permanent Alizarin Crimson • Prussian Blue • Winsor Green (Yellow Shade)

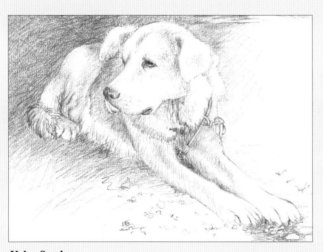

Value Study

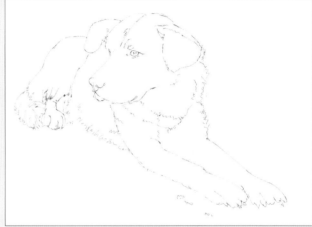

Drawing

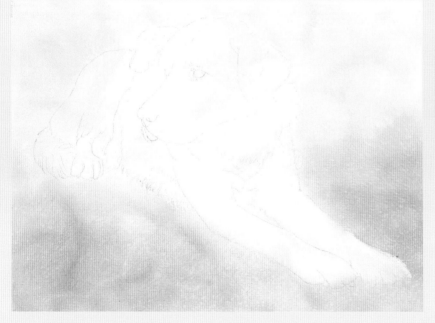

1 Apply the First Background Wash
Apply masking where the lightest parts of the dog's fur meet the background. Next, using the larger hake, wet the entire surface with water, then apply diluted Aureolin at the top of the painting. Apply Burnt Sienna on the bottom part with the smaller hake. Let this dry.

Need More Realism? Think Value

As you already know, it takes more than one element to create a representational painting. One of the most important elements necessary to create the illusion of a three-dimensional image is value. Simply put, light values advance and dark values recede.

Playing up the value to create the illusion of a realistic image is exactly the same when painting something small, such as a little bird's eye, or something very large, such as an elephant's body. Some images will be more complicated than others, but how far you want to take your painting is up to you. How realistic and to what level of detail you plan for your painting will determine how many steps you will need to create the painting.

2 Apply the Second Background Wash
Apply the same colors for the second background wash using thicker, stronger Aureolin and Burnt Sienna. This application starts to separate the dog from the background. Let this dry.

3 Apply a Cooling Wash
Wet the entire surface with water, then apply Prussian Blue over the whole background. Use a dry hake to feather blue toward the dog to avoid a hard edge between it and the background.

4 Establish Depth

In order to better define the space the dog is in—an open field—use aerial perspective in the background to give the composition some depth. You can always change it later if it doesn't work the way you want.

Apply a mixture of Indigo, Sepia and Winsor Green at the top of the painting for the sky using a no. 16 round. Then, feather out the bottom edge of the sky area application with a clean, damp brush. Add a little gravel to the ground with a no. 4 round using a mixture of previously used leftover colors.

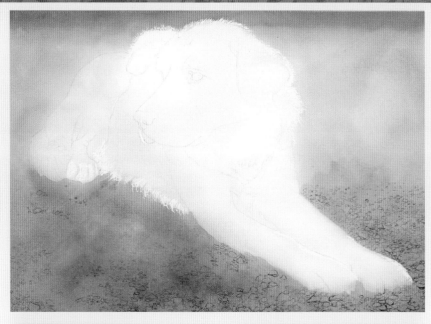

5 Develop the Background Further

Apply masking on the new gravel to save the highlights. Then, use a no. 16 round with previously used leftover colors to glaze distant mountains to suggest a break between the sky and ground. After the mountains dry, prepare a diluted mixture of Permanent Alizarin Crimson, Sepia and Indigo. Wet the background with clean water before using a dry 2½-inch (89mm) hake to apply a concentrated mixture of paint on the top and bottom parts of the painting to darken them. The darkened background will push you to make the main subject strong enough to stand out against its dark surroundings.

6 Apply the First Glaze on the Subject

Use small amounts of Aureolin, Permanent Alizarin Crimson and Burnt Sienna to make various combinations for glazing the shaded areas of the dog using nos. 8 and 10 rounds. Glaze these areas section by section rather than all at once. Apply a second glaze if you want the areas to be darker after the first glaze dries. This undercoat will be the light part of the subject.

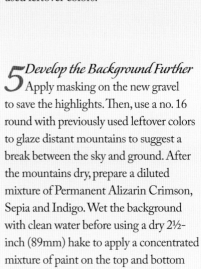

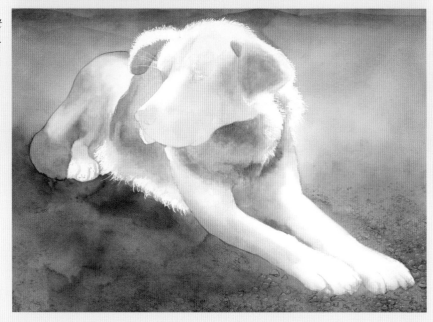

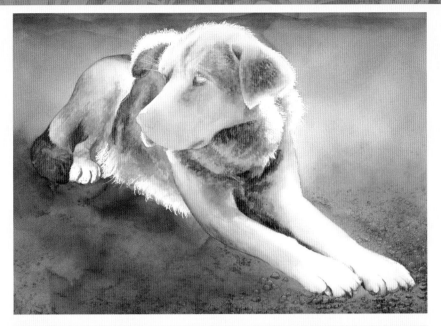

7 Apply the Second Glaze on the Subject

Use Permanent Alizarin Crimson and Sepia with a no. 6 round to glaze and further darken the shaded areas and around some of the gravel near the front paws.

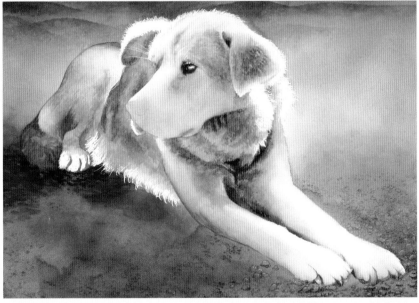

8 Apply a Cooling Glaze on the Dog

Using a no. 16 round, apply a very light coat of Prussian Blue on the dog, avoiding the highlight areas. Use a diluted mixture of dark colors—Indigo, Permanent Alizarin Crimson and Sepia—to create slight texture on the upper background. Use the glazing technique to add darker details here and there to improve the harmony of the painting. Stand back, look at the painting and consider whether the added darks are enough to make it ready for you to add the final details.

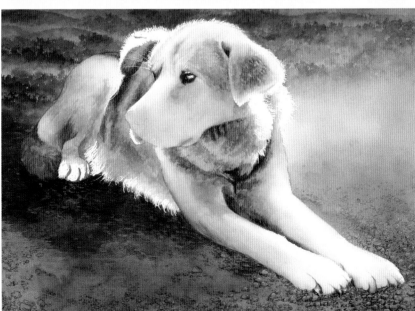

9 Improve the Background

Before finishing a painting, you may find it necessary to make small changes to your original plan. In this case, I decided to change the upper background, softening it to give a better feeling that the dog is in an open space. Using an old chopped brush, apply the same mixture of dark colors from step 8 in a stamping manner, alternating the density of the paint. Glazing with the same dark mixture, start to develop the darker areas of the dog and the foreground.

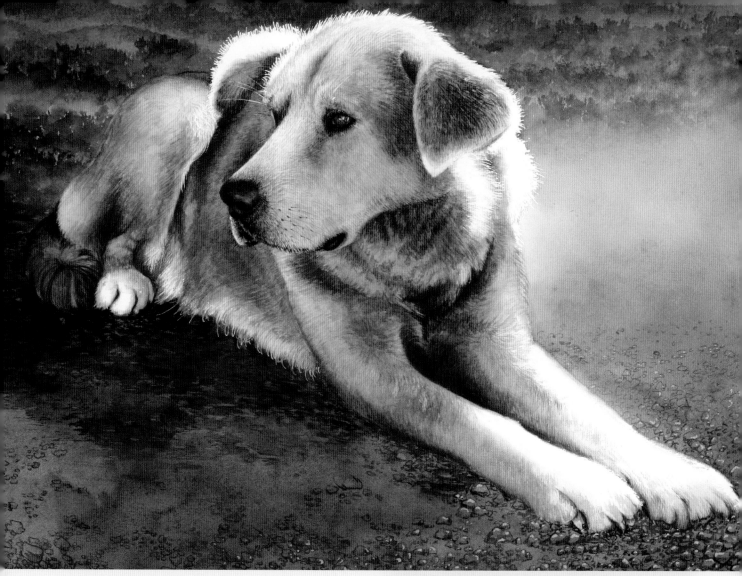

10 Add Final Details

Remove all the masking. Define the fur by using a choppy dry-brush technique with nos. 6 and 8 rounds. For the lighter areas, use a thinned mixture of Permanent Alizarin Crimson, Burnt Sienna and Sepia. For the darker areas, add Indigo to this mixture. For the dog's nose, eye and mouth, add Prussian Blue and Indigo to the mixture to make bluish black, and alternate the same brushes to detail the face.

Noorung-ee
Watercolor on Arches 140-lb. (300gsm) cold press
21" x 29" (53cm x 74cm)

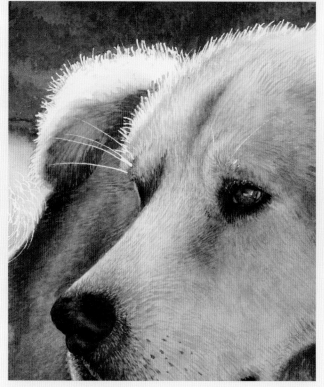

Detail

Use Perspective to Play Up Your Subject

In Venice, every opening or corner around the city has the potential to become an eye-popping, beautiful painted image. Of course, the most renowned Venetian subject is a canal. When you are looking at a canal alongside a building, the possibility of rendering the scene in one-point perspective is obvious, as demonstrated here. One-point perspective will create an interesting composition that naturally conveys the canal's path.

To capture the feel of the old buildings and to be sure the scale and perspective are correct in the final painting, the initial drawing is tight and detailed. You can loosen up and get more expressive during the painting process if desired. A detailed study of the buildings affords you the freedom to explore more playful options without sacrificing the correct proportions.

Materials

Arches 300-lb. (640gsm) cold press • masking fluid • nos. 8, 10 and 16 rounds • 3½-inch (89mm) and 2½-inch (64mm) hakes

Watercolors

American Journey: Burnt Sienna

Da Vinci: Cerulean Blue Genuine

HWC: Indigo

Winsor & Newton: Aureolin • Permanent Alizarin Crimson • Prussian Blue • Sepia

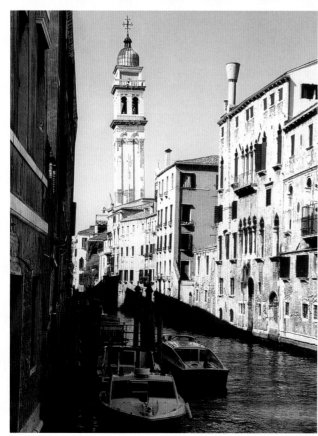

Reference Photo

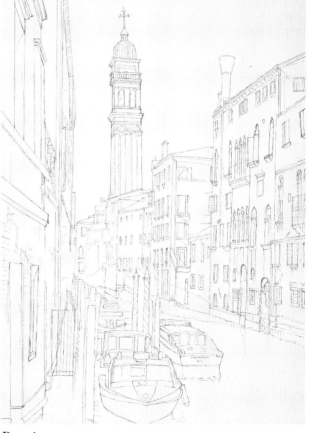

Drawing

Put All Things in Perspective

Perspective creates the visual sensation of depth in an image on a two-dimensional surface. As objects recede into the distance, they appear smaller as they approach the vanishing point. Perspective is necessary for representational painting, since perspective is present, even in a simple still life or—more obviously—a complicated street scene. When something is not quite right in a composition, it may well be that the perspective is a little off in an object. Look at everything. It could be a pot of flowers sitting on a table, or the angle of the window in a building needing a little more slant.

After you finish a drawing, use both technical and artistic skills to study it carefully. Also look at it intuitively to make sure you are satisfied with the overall composition. Prop it against a wall and evaluate it from a short distance. If something doesn't stand out and bother you, the drawing is probably fine. When painting with watercolor, it is usually best to make corrections before any paint touches the paper, or at least before you complete the initial washes.

1 Apply a Yellow Underwash
Apply masking fluid to save the lightest areas of the buildings that line the canal and also to protect some highlights on the boats and in the water. After it dries, use the larger hake to wet the paper, and then apply thinned Aureolin gently over the wet surface. Let it dry.

2 Add a Warm Wash
Mix fairly concentrated Permanent Alizarin Crimson and Burnt Sienna on a separate palette. Wet the entire paper with clean water using your larger hake. Then gently apply the paint mixture with the smaller hake, making the shaded sides of the buildings and the water area a little darker. The sky should remain lighter.

3 Add a Cool Wash
Apply thinned Prussian Blue to the painting with the same size hakes as in the previous step. The cool blue calms the entire painting at this stage.

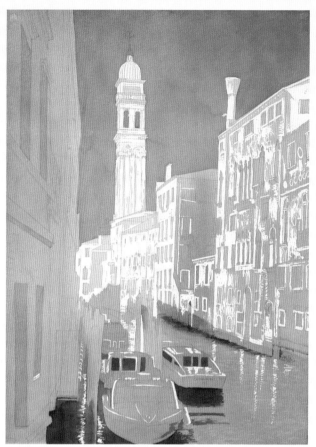

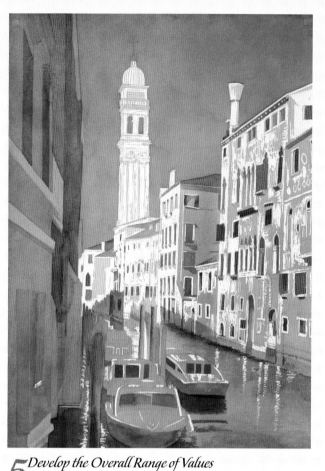

4 Reinforce Areas of Cool Color

Reinforce the cool wash on the shaded areas and bring out the rich blue sky by applying a thinned mixture of Prussian Blue and Indigo on the sky and the bottom part of the painting. After it dries, apply slightly thicker pigment with a no. 10 round to further define the water and boat. For the sky, apply Cerulean Blue Genuine with a no. 16 round.

5 Develop the Overall Range of Values

Use masking fluid to save the lighter areas on the buildings on the right, then develop the darker values little by little. Applying thinned color creates a lighter effect on the left side of the painting. Apply a mixture of Indigo and Prussian Blue on the building on the left and on the boats with a no. 16 round. Continue applying the mixture on some of the windows and along the bottom of the buildings on the right. Also, apply a mixture of Permanent Alizarin Crimson and Burnt Sienna with a no. 8 round on the windows of the buildings on the right. Glaze the same mixture onto the water and the building on the left where the reddish color is present. Finish defining the values before moving on to the next step.

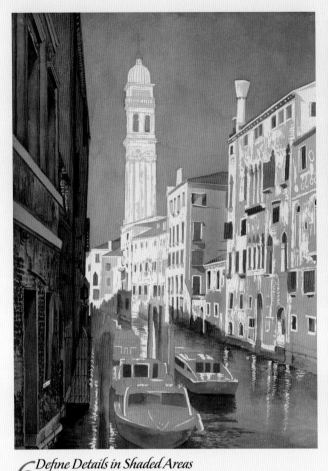

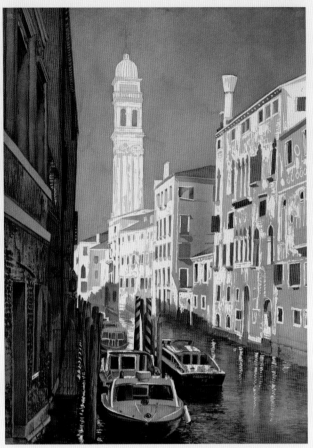

6 *Define Details in Shaded Areas*
Use a no. 8 round for this step. Apply a light mixture of Aureolin and Burnt Sienna for the lighter wall texture, and a mixture of Permanent Alizarin Crimson and Burnt Sienna to create the bricks on the bottom of the building. Then, alternating creamy darks made with various combinations of Indigo, Prussian Blue, Sepia and Permanent Alizarin Crimson, start to develop the shadows of the brick, windows and street lights, and the dark reflection in the water. To revitalize the light blue reflection of sky that is lost in the water, apply Cerulean Blue Genuine on the middle of the water. The middle value of the painting—established on the building on the left—will guide you in the creation of the darkest values of the water and the lightest values of the buildings on the right.

7 *Define Darks in the Water and on the Boats*
Since you now have a variety of darks on your palette, it is convenient to continue developing the darkest values of the picture. Using a no. 8 round, start to define the boats and the water. If needed, add more paint to the Indigo, Sepia, Permanent Alizarin Crimson or Prussian Blue on the palette.

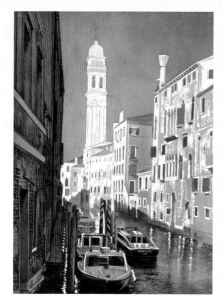

8 Remove the Masking

After removing the masking fluid, it's easy to see that the resulting white, especially in the darker areas, stands out too much.

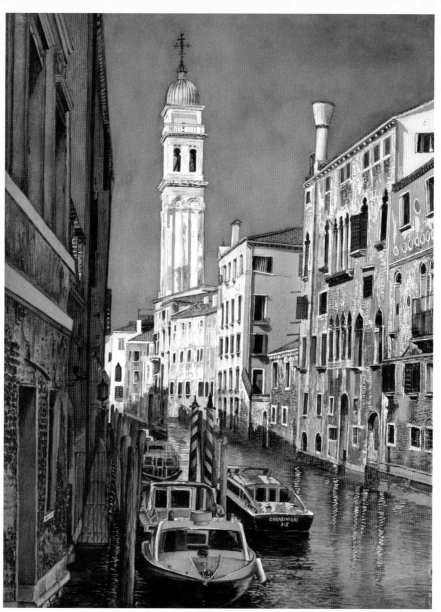

9 Tone Down the Bright Whites

Apply thinned bluish or reddish colors on the unmasked whites. After they dry, define the little details. Re-creating the texture of a weathered building façade can be a bit tedious, but without it, the effect of this painting would be weaker. With all the colors from the previous steps and a no. 8 round, drybrush to create the rough surface of the closest building and its windows' dark shadows. Finish developing the painting's details using the same brush and colors. Deepen the sky with one more glaze of the Cerulean Blue Genuine and Prussian Blue mixture, applied with a no. 16 round.

The rich colors and textures bring out the beauty of the aged building, while the broad value range stimulates slow, lingering eye movement around the picture. The focal point—the tower showered with light—stands quietly before the viewer's eyes, anchoring another beautiful corner of Venice.

Tower in Venice
Watercolor on Arches 300-lb. (640gsm) cold press
30" x 22" (76cm x 56cm)

Don't Shy Away From Intense Primaries

Sometimes, the odd and unusual get more attention than the ordinary. In this painting, the movement of the constantly changing primary-color reflections is more interesting and exciting than just a stack of boats. The impermanent image made by the fleeting light seems fragile, but—while it is in front of me—I want to grab it. I want to capture the fascinating temporary scene that will disappear, in time, with the sunlight.

The water's reflection of primary colors comes from the manmade colors of the boats. These intense hues stand out from the neutral gray without any need to emphasize them artistically. In this painting, a light blue wash will be the lightest highlight. Then, each component of the image will be developed by direct glazing, a controlled technique that eliminates the need for masking fluid to save whites. In the first few steps, all the colors will be applied in clean glazes, with no blending.

Materials

Arches 300-lb. (640gsm) cold press • nos. 4, 8 and 10 rounds • 3½-inch (89mm) and 2½-inch (64mm) hakes • old chopped brush

Watercolors

American Journey: Burnt Sienna

Da Vinci: Cadmium Yellow Medium • Cerulean Blue Genuine

HWC: Indigo • Lemon Yellow

Winsor & Newton: Hooker's Green • Permanent Alizarin Crimson • Prussian Blue • Scarlet Lake • Sepia

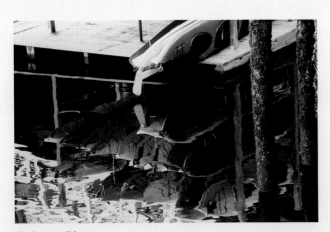

Reference Photo

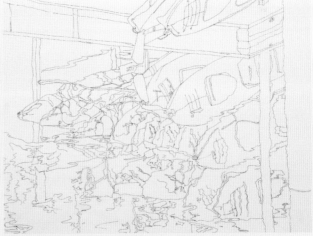

Drawing

This tight drawing has as much detail as possible, especially for the larger shapes. It will guide the direct glazing process much faster than a loose brush drawing would.

Pure Primaries: Natural Harmony

Unless you are viewing a scene that is either monochromatic or black and white, the three primary colors—red, blue and yellow—each will be present to a greater or lesser degree. To the extent you mix your colors or use them straight out of the tube, painting only with primaries will bring out the brilliance of our environment. All that remains for you to control are the levels of intensity and value. Have fun with colors that are bright and saturated, the way nature intended us to see them!

1 Establish the Lightest Areas and a Few Darks

Prepare thinned Prussian Blue, and then wet the paper with clean water and your larger hake. Apply the blue on the wet surface gently with the smaller hake. This blue will become the painting's cool highlights.

Add more Prussian Blue to darken the value. Apply it on the dark areas of the picture with a no. 10 round, painting around the lighter areas.

2 Apply a Yellow Undercoat

With a no. 10 round, apply Lemon Yellow to block in the lighter yellow areas. For the darker yellow areas, use Cadmium Yellow Medium.

3 Add a Red Undercoat

Using a no. 10 round, block in the red areas with Scarlet Lake and Permanent Alizarin Crimson. Refer to the reference photo as needed to see which areas are this color. So far, all the colors have been applied in clean glazes, with no blending.

4 Glaze the Wooden Dock and Post
Using a no. 10 round, apply thinned Burnt Sienna on the areas of wood surface—the dock and post—as well as their reflections. Develop the shaded areas of the wood with the same color in a darker value. Use a chopped brush to create bumpy texture on the large post on the right.

5 Define the Water
Use various thinned mixtures of Burnt Sienna and Prussian Blue to draw the wavy lines of the water at the bottom of the painting with a no. 4 round.

6 Glaze the Yellow and Red Boats
To intensify the color of the boats, glaze a thick mixture of Lemon Yellow and Cadmium Yellow Medium for the lighter yellow areas of the boats using a no. 8 round. Next, mix Scarlet Lake into the yellow mixture for the light orange parts of the boats, using a no. 8 round. For the reflected red boats, mix Scarlet Lake and Permanent Alizarin Crimson with touch of Sepia to make a darker red, then glaze on the resulting mixture.

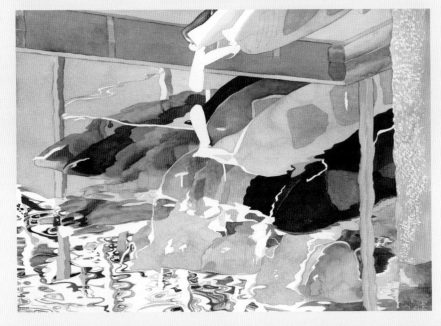

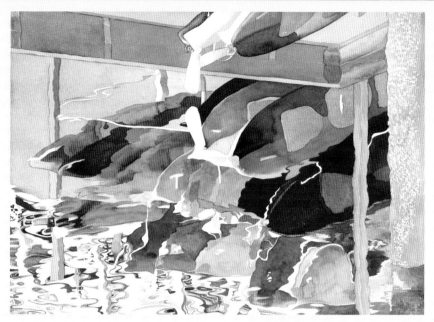

7 Glaze the Blue Boats

With a no. 8 round, glaze Cerulean Blue Genuine on the lighter sides of the blue boats. Mix in some Prussian Blue to glaze the dark sides of the blue boats.

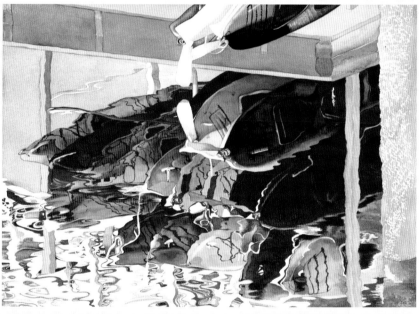

8 Define the Boats With Darker Colors

First, make a thick mixture using the dark colors Sepia, Prussian Blue, Indigo and Permanent Alizarin Crimson. With a well-thinned version of the mixture and a no. 8 round, glaze where darker shades are necessary on the red, yellow and blue boats. Then define the dark lines on the boats with the original, thicker mixture and a no. 4 round. After you develop the dark shades and details, the boats will start to sparkle.

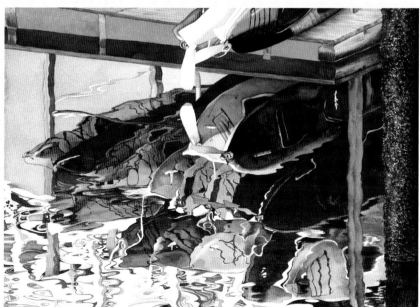

9 Develop the Wooden Post and Dock

With a no. 8 round, glaze with the thinned dark mixture used in the previous step to darken the values of the large wooden post on the right and the dock. Then, using the thicker dark mixture from the previous step, start to develop the post and the dock. With the same brush, apply Hooker's Green on the post sparingly to portray the moss.

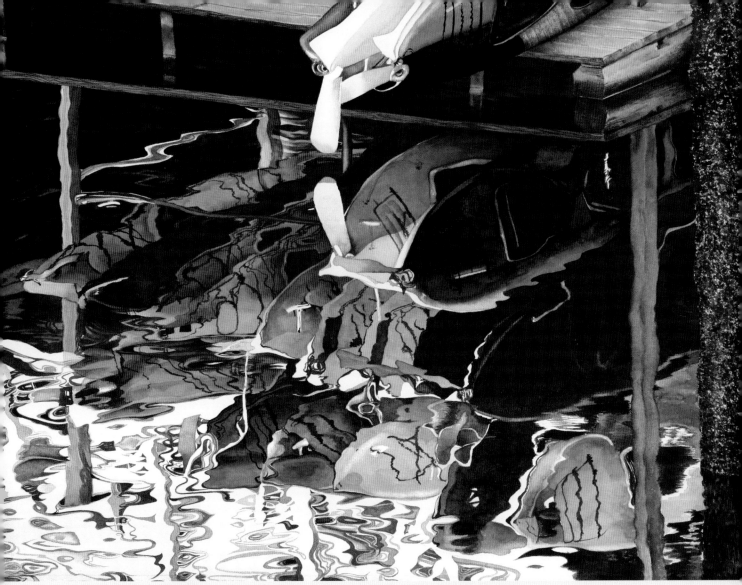

10 Finish the Darkest Parts of the Water and Dock

Apply the dark colors used in previous steps to the darkest parts of the dock and to the water under it. Instead of applying the colors evenly, play with creating wavy lines, a continuation of the water's light reflections from the bottom of the painting. The neutral but busy background complements the intensity of the primary colors, creating a sense of balance.

Canoes
Watercolor on Arches 300-lb. (640gsm) cold press
22" x 30" (56cm x 76cm)

Boost Surrealism With High Value Contrast

Does every painting need a deep, intellectual meaning? Isn't it reason enough to paint something because you like it, because it is simply beautiful, or because it evokes an emotional reaction? For each painting, an artist creates a uniquely interesting composition by using a combination of instinct and education, unifying many elements to form a satisfying design.

This reference photo grabbed my attention due to its surreal feeling: The daffodils are in the glass but appear to float in the dark air. I like the contrast of the dark background and the light flowers as they boldly clash into each other, both with a firm claim on their own space. Is that a good enough reason for me to paint? Yes!

Materials

Arches 300-lb. (640gsm) cold press • masking fluid • nos. 8 and 10 rounds

Watercolors
Daniel Smith: Quinacridone Violet

HWC: Indigo

M. Graham: Ultramarine Blue

Stephen Quiller: Gamboge

Winsor & Newton: Aureolin • Hooker's Green • Permanent Alizarin Crimson • Scarlet Lake

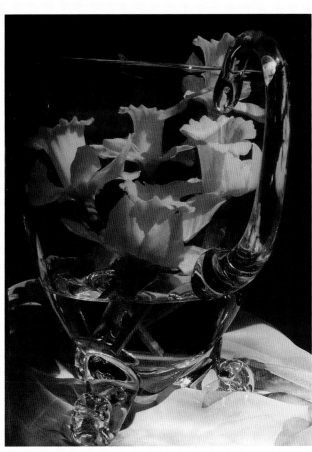

Reference Photo

Drawing

Contrast Stirs Instant Interest

One way to transform a dull, uninteresting painting into an eye-catcher is to increase the level of contrast, perking up the picture. Adding contrast is the easiest way to bring out the life in a painting.

Use value, saturation and complementary colors to provide contrast. Take full advantage of the color theory guidance in chapter 2 to avoid such problems as muddy colors, which can sabotage good contrast. The degree of contrast can (and should) be different for each painting and may be distinctively different from one artist to another. Be a little daring and explore more contrast in some of your paintings!

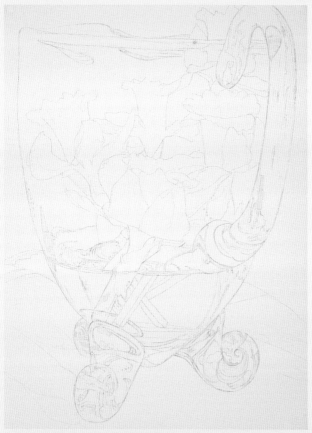

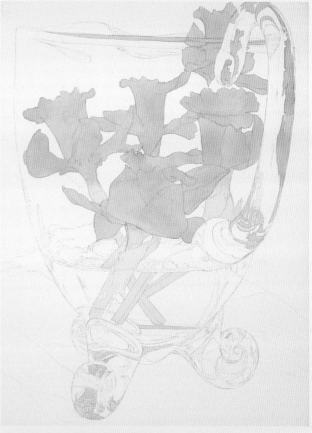

1 Carefully Preserve Highlights
Apply masking fluid on as many of the highlights of the glass vase as possible. When you prepare the light areas of the painting well, adding darker values in later stages of the process becomes much easier. You'll spend less time scrubbing to reclaim highlights or trying to change the shape to accommodate the loss of highlights.

2 Apply a Yellow Undercoat
Mix a rich, dark yellow with Aureolin and Gamboge on your palette to undercoat the daffodils. Apply an even layer on the flowers with a no. 10 round. This local, saturated yellow will be able to compete properly with the black background in the final painting. Let it dry.

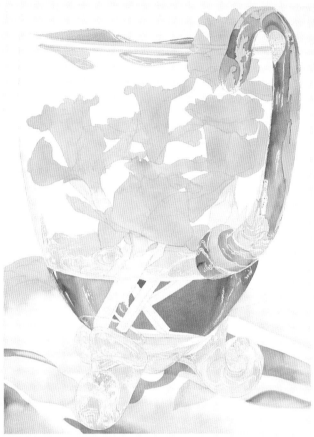

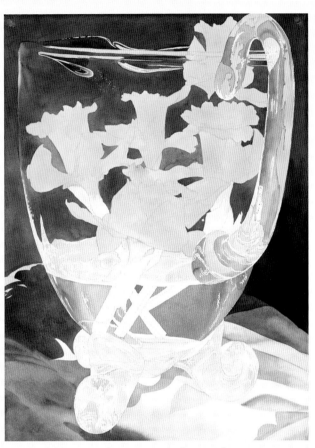

3 Begin the Glass and Cloth

Glaze thinned Ultramarine Blue inside the glass and on the cloth with a no. 10 round. Glaze Quinacridone Violet where the reddish color appears in the cloth and on the reflections in the glass.

4 Apply a Complementary Background

Mix Ultramarine Blue, Quinacridone Violet and Indigo on a palette. Apply it on the background with a no. 10 round. The bluish purple is the complementary color of the rich yellow, so it establishes a strong contrast. Glaze to develop the cloth, using the same colors and brush.

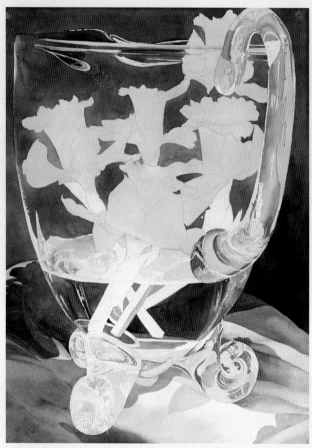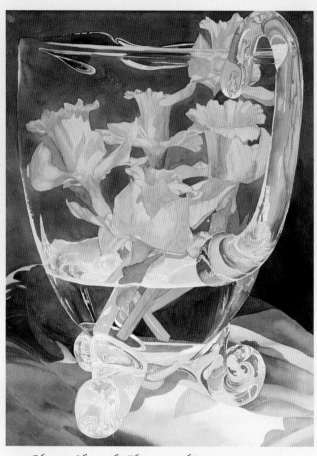

5 Glaze the Red Areas

Glaze highly thinned Permanent Alizarin Crimson on the red areas on the right side of the cloth. Glaze this red on the left side of the cloth as well to further define it. Next, with a no. 8 round, glaze the reflected red that spreads in the glass to unify the picture.

6 Glaze to Shape the Flowers and Stems

Using a thick, darker yellow mixture of Gamboge and Scarlet Lake and a clean, damp no. 10 round, glaze the flowers to give them shape and dimensionality. With the same brush, glaze a moderately thinned mixture of Hooker's Green and Permanent Alizarin Crimson on the darkest parts of the stems to prepare for the final details.

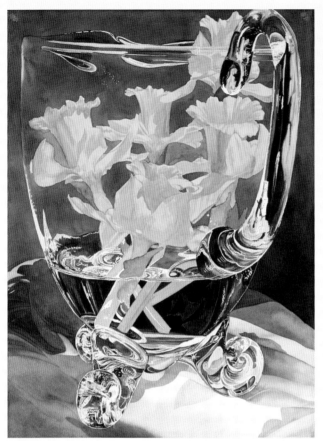

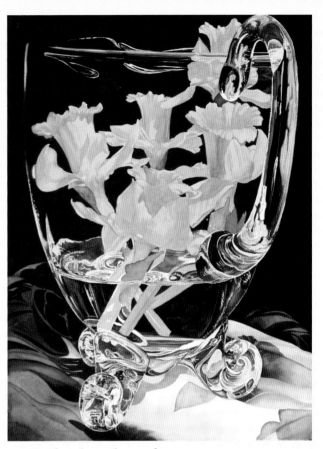

7 Develop the Glass

With a no. 8 round to define the details of the glass, draw lines and fill in the darker areas with a mixture of Ultramarine Blue, Quinacridone Violet and Indigo. Use clean, sharp lines, with limited blending and feathering. The masking fluid is still on the paper to save the highlights. At this stage, note the contrast between the background and the defined details in the glass to get an idea of how dark you will eventually want the background to be.

8 Darken the Background

Apply the same dark mixture from the previous step to the glass and background. Continue to glaze the same dark color on the cloth. The darkness of the background should be consistent from top to bottom. With a no. 8 round, glaze thinned Permanent Alizarin Crimson to reinforce the red on the cloth.

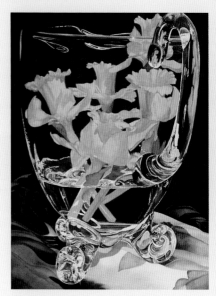

9 *Masking Fluid Comes Off*
Remove the masking fluid.

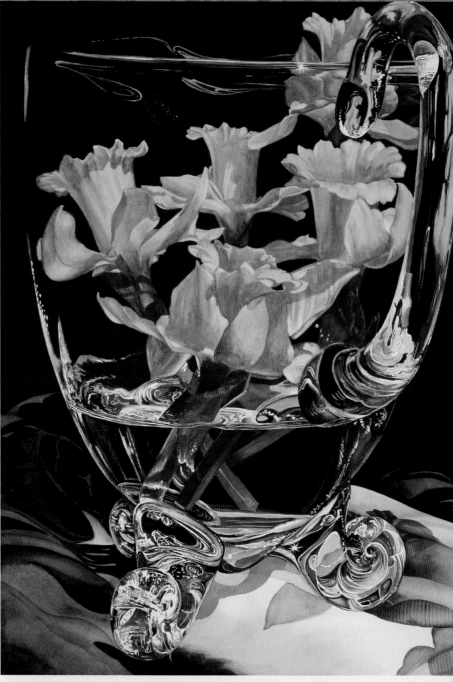

10 *Finish the Flowers and Make the Glass Shine*
Define the flowers' shadows with the dark mixture from step 7, using a no. 8 round. Thin it with a lot of water and use it carefully; otherwise the dark color may easily overpower the yellow. With the same brush and dark mixture, define the glass. At this point, you may find it necessary to scrub off a hard edge or two before adding further definition with sharp lines. To create a high range of contrast within the glass, leave some sharp white lines adjacent to dark lines. This makes the glass appear to sparkle.

Daffodils in the Glass
Watercolor on Arches 300-lb. (640gsm) cold press
30" x 22" (76cm x 56cm)

Simple Background, Striking Focal Point

It is always fun to paint a feathered friend, especially a colorful one. The moment that these three birds isolated themselves from the flock, sitting on a branch, was the perfect time for me to capture the image. In this painting, the center of interest is unmistakable. The background color is kept neutral and the design simple, ensuring that the bright birds get all of the attention.

In this demonstration, glaze each color layer by layer, from start to finish. Paint the subject and background separately to maximize the contrast—another technique to focus attention on the subject.

Materials

Arches 140-lb. (300gsm) cold press • masking fluid • nos. 4, 8, 10 and 12 rounds

Watercolors

American Journey: Sour Lemon

Daniel Smith: Quinacridone Burnt Orange • Quinacridone Violet

Da Vinci: Cerulean Blue Genuine • Payne's Gray

M. Graham: Ultramarine Blue

Stephen Quiller: Gamboge

Winsor & Newton: Aureolin • Hooker's Green

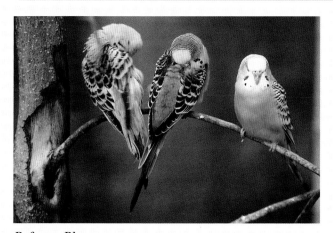

Reference Photo

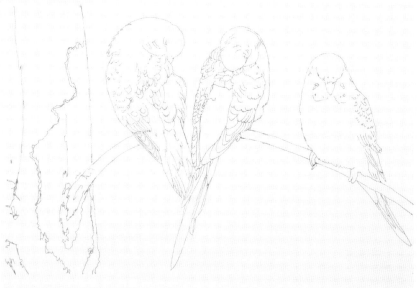

Drawing

The Center of Interest: Point of Departure and Destination

Usually the center of interest will not only act as the focal point of the picture, but will initiate the viewer's journey throughout the painting. The easiest way to begin leading the eye is to place the subject on a blank background. The viewer's eye will unquestionably be drawn to a subject isolated on a featureless background. Artists usually devise other ways to captivate the eye and lead it around a painting, but whether the composition is simple or complex, a strong center of interest is essential. It is the place where the viewer begins considering a painting, so it is where you, the artist, should begin, too.

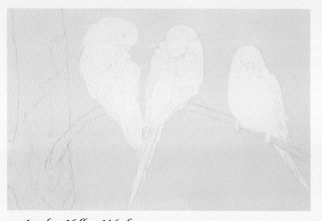

1 Apply a Yellow Wash
Apply highly diluted Aureolin uniformly with a no. 12 round everywhere but where the birds are. The yellow undercoat darkens the background to enhance the eventual contrast in intensity between it and the subject: the bright birds.

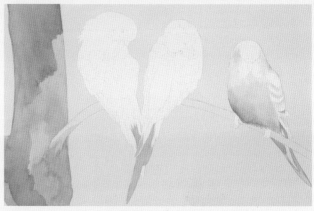

2 Begin Developing the Birds and Tree
With a no. 8 round, glaze a mixture of Cerulean Blue Genuine and Ultramarine Blue where the feathers are blue. Immediately after completing the right bird's chest, and using a clean, damp brush, feather the paint off its chest to make it a lighter blue. While the blue is drying, apply an undercoat on the entire tree trunk with heavily thinned Quinacridone Burnt Orange. While it is wet, loosely apply somewhat less thinned Ultramarine Blue on the bluish outer bark of the tree.

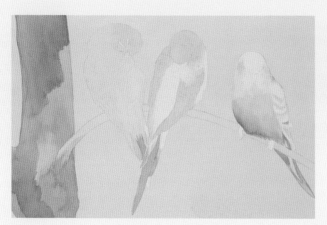

3 Add Yellow to the Birds
Apply thinned Gamboge on the head of the bird on the left. Change to similarly thinned Sour Lemon to finish the head's undercoat with a no. 8 round. On the middle bird, apply thinned Gamboge for the wings' undercoat and the head with the same brush.

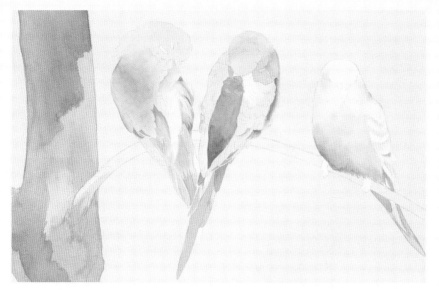

4 Glaze On Light Green
Add yellow feathers to the left and middle birds by glazing a mixture of Aureolin and Gamboge with a no. 8 round. Glaze the same birds with somewhat thinned Hooker's Green. Note that the middle bird's green is more intense than that of the bird on the left. Therefore, apply a slightly thicker green on the middle bird, and a thinner green on the left bird.

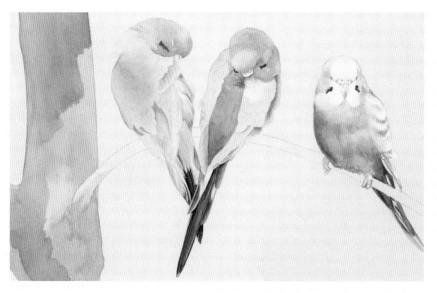

5 Define the Blue Tails
Starting with a moderately thinned mixture of Cerulean Blue Genuine and Ultramarine Blue, define the blue tails of the birds with a no. 4 round. Add Quinacridone Violet to the mixture, creating a darker blue to give depth to the feathers. Apply this to darken the centers of the blue feathers. Glaze a darker yellow mixture of Gamboge and a touch of Quinacridone Burnt Orange on the green birds' heads with a no. 8 round. Notice that the beak area of the birds is much darker than the rest of the head.

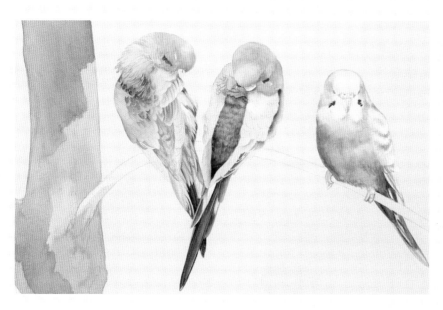

6 Define the Green Feathers
With a very thin mixture of Hooker's Green and a touch of Quinacridone Violet, define the details of the two green birds' feathers with a no. 8 round.

7 Lay In the Background

To make cool, dark black, mix Payne's Gray and Ultramarine Blue on a separate palette. Use enough to cover the background and all of the darkest areas of the birds and tree. Using a fully loaded no. 10 round with a well-pointed tip, start washing in the color at a corner of the picture. Apply enough paint to puddle the color at the end of the brushstrokes. Pull the puddle until all of the dark background areas are covered.

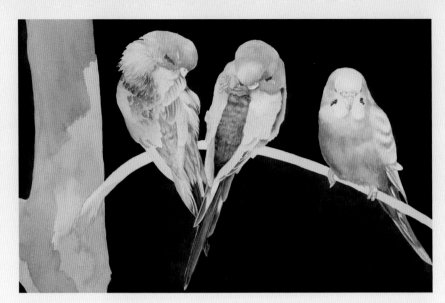

8 Work on the Tree Trunk

To save time, apply dots on the bark of the tree trunk using masking fluid. After it dries, use a no. 8 round to glaze a very thin mixture of Quinacridone Violet plus a small amount of the dark background color to darken the bark of the tree trunk. Next, glaze moderately thinned Quinacridone Burnt Orange on the bare side of the branch and the trunk with the same brush.

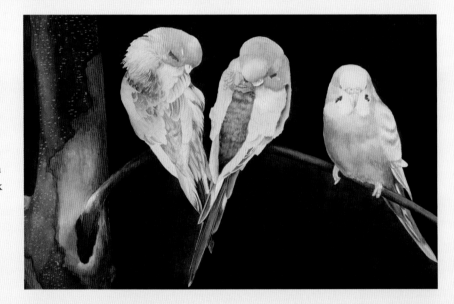

Mixing on Separate Palettes

From time to time, you will want to mix a large quantity of a color that is incompatible with the colors on your palette. The solution to this problem is to mix the new color on a separate palette. Otherwise, you risk contaminating and ruining your beautiful palette colors! If you don't have an extra palette handy or wish to economize, try using a plate instead. Foam plates work great because you can discard them when you're finished. A second alternative is a nonstaining plate from your cupboard. To test whether a plate will stain, apply a small amount of color on the bottom of the plate. Let it dry. If it washes off without staining, you have your separate palette!

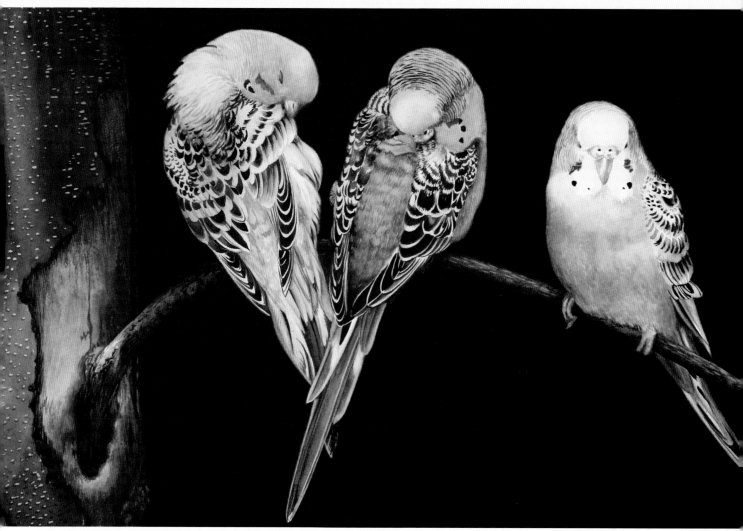

9 *Punch Up the Darks*

Gently scrub any sharp outlines of the birds to soften them and eliminate the paper-cutout look of the light birds against the dark background. Start to define the birds' darkest feathers with a no. 4 round and the dark mixture used for the background. Next, remove the masking fluid from the tree. Using the dark background mixture, create the appearance of depth around the tree's bare areas with the drybrush technique. Add other hues, if you wish, as you make final adjustments. Even out the background by applying more of the same dark mixture with a no. 12 round.

Parakeets
Watercolor on Arches 140-lb. (300gsm) cold press
14" x 21" (36cm x 53cm)

Focus All Eyes on the Details

These freshly popped, white pear tree blossoms show-case early spring's natural beauty. To give undivided attention to a subject's details, one idea is to crop out part of a more expansive scene. Focusing on a cluster of blossoms doesn't compromise the setting too much and allows you to retain the natural outdoor surroundings while indulging in some stunning details. The naturally arranged blossoms create a beautiful arch that provides a clear center of interest for this painting.

Materials

Arches 140-lb. (300gsm) cold press • masking fluid • nos. 8 and 10 rounds • stiff old short-haired brush

Watercolors

Daniel Smith: Quinacridone Burnt Orange • Quinacridone Violet

Da Vinci: Cadmium Yellow Medium • Cerulean Blue Genuine

HWC: Indigo

Stephen Quiller: Gamboge

Winsor & Newton: Aureolin • Hooker's Green • Scarlet Lake • Sepia • Titanium White

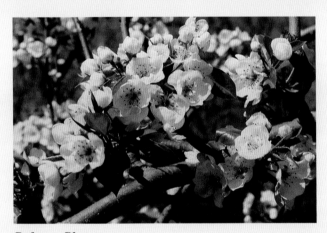

Reference Photo

Drawing

1 Give Initial Definition to the Flowers

Use masking fluid on the stamens to save the light part of the filaments. Apply a highly diluted mixture of Indigo and Quinacridone Violet on the shaded areas of the flowers with a no. 8 round.

2 Lay In the Background Color

Apply thinned Cerulean Blue Genuine on the background, starting with the darkest blue first. Continue to further thin the pigment to paint the lighter blue areas. The light flowers start to take shape as you surround them with background color using a no. 8 round.

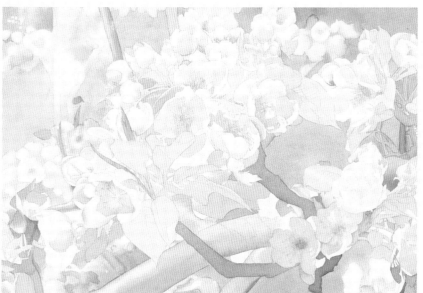

3 Undercoat the Leaves and Branches

Apply a thinned mixture of Aureolin and Cadmium Yellow Medium on the leaves. Lightly apply this mixture on the flowers in the background and on the flower centers with a no. 8 round. Apply Quinacridone Burnt Orange on the lighter branches. For the darker branches, apply a thinned mixture of Indigo and Quinacridone Violet for the undercoat.

4 Start Defining the Leaves

Using a no. 8 round, start to define leaves one by one. Apply a mixture of Gamboge and Scarlet Lake on the reddish leaves. Next, mix a medium-dark color using Hooker's Green and Quinacridone Burnt Orange. Use the same brush with this mixture, glazing it on the green leaves. To paint the darkest parts of the leaves, add Indigo to the mixture. Introducing yellow and red into your green mixtures creates vibrant and refreshing young leaves.

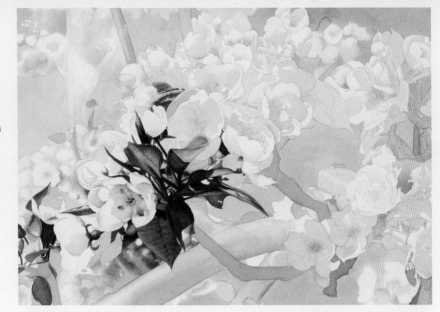

5 Finish Defining the Leaves

Continue defining the details of the leaves as much as possible, as in the previous step. The contrast introduced by the dark leaves makes the white flowers begin to sparkle.

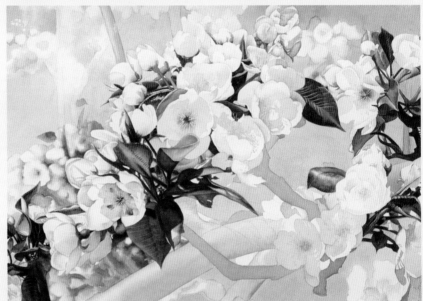

6 Define the Flowers

Start to define the flowers with a thinned mixture of Quinacridone Violet and Indigo for the petals that are in sharp focus. For the centers of the flowers, add Quinacridone Burnt Orange and Hooker's Green to mix a dark color. Apply the dark color to the center of the flowers, and feather it out with a clean, damp no. 8 round. Apply the same dark color on most of the anthers, adding a touch of Scarlet Lake for the reddish color. The masking fluid is still on the stamens in this step.

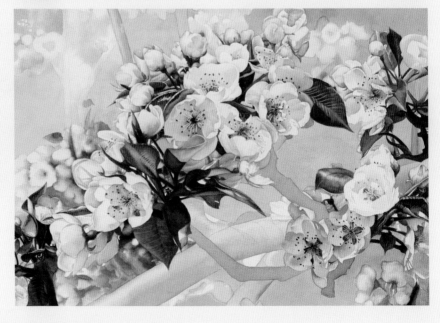

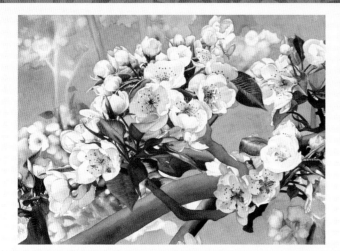

7 Work on the Background

With a no. 10 round, apply Cerulean Blue Genuine on the background to deepen the blue. Darken the smaller bluish branches with a mixture of Indigo and Quinacridone Violet. Glaze the same mixture, only thinner, for the thicker reddish branches. After this dries, apply thinned Quinacridone Burnt Orange with the same brush to create the reddish look.

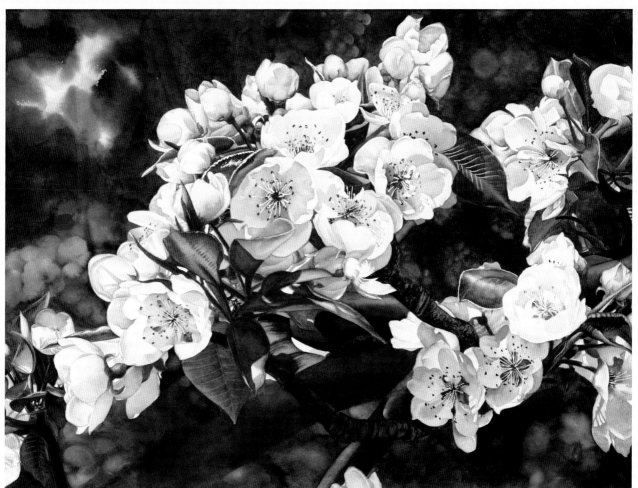

8 Make Adjustments

While I was defining the tree, the thick branch became too dominant. The planned light background does not quite work with it. After several unsuccessful attempts to change the branch, the solution was to change the Cerulean Blue background to a dramatically darker blue. Apply a mixture of Indigo and Quinac-ridone Violet over the background with a no. 10 round, avoiding laying color too heavily in the lighter background flower areas. Apply opaque Titanium White to define the background blossoms otherwise lost in the darkness. The result is that the blossoms get more attention without distraction. Remove the masking fluid from the centers of the flowers.

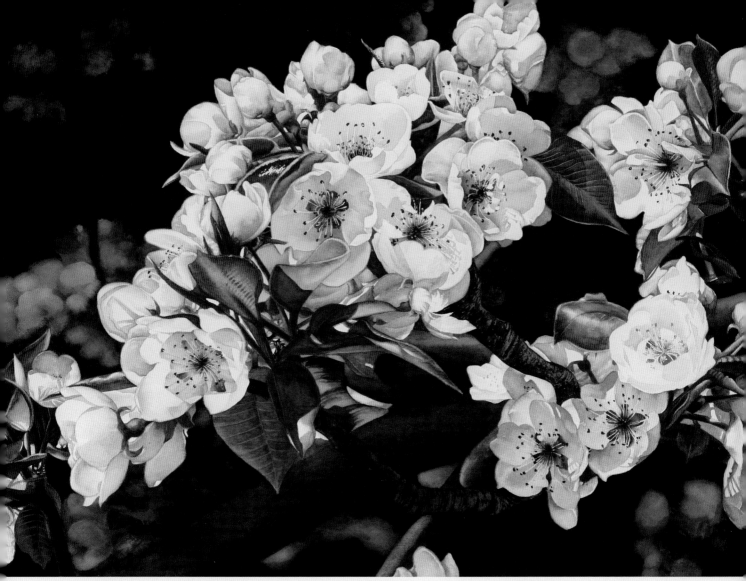

9 Add Details to the Blossoms

Define the centers of the flowers with a darker mixture of Hooker's Green and Indigo. Using several variations and combinations of Quinacridone Burnt Orange, Hooker's Green and Aureolin, paint the dots of the anthers where the tips of the light filaments are. Using a no. 10 round, darken the background with a mixture of Indigo, Quinacridone Violet and Sepia, further reducing the distraction from the flowers. Redefine the background blossoms with opaque Titanium White to bring out the light. Use a stiff old short-haired brush to scrub some of the edges of the light flowers against the dark background to soften the paper-cutout look.

After you finish the painting, prop it up against a wall and step away from it. Squint to look for any elements that stand out too much, areas to tone down or dead spots that need to be brought back to life. A little nip and tuck may make the painting livelier.

Pear Blossoms
Watercolor on Arches 140-lb. (300gsm) cold press
22" x 30" (56cm x 76cm)
Collection of Peter and Alice Haslam

Achieve Balance Through Repetition

Upon seeing these windows lined up in Venice—all similar, yet each having its own unique characteristics—I immediately decided to snap a picture. The windows create visual interest over the entire surface. In this painting, instead of creating one center of interest, I allowed all the architectural elements of the building's exterior to get equal attention to balance the composition. The repeating windows, arches, columns and balconies compose a narrative of historical and visual interest. The façade contains an encyclopedia of history's architectural features: various types of Greek columns, to Roman, Moroccan and Gothic arches, and three styles of balconies, including one in modern wrought iron!

Materials

Arches 200-lb. (425gsm) cold press • nos. 4, 6, 8 and 10 rounds • old no. 12 round • 2½-inch (64mm) hake

Watercolors

American Journey: Burnt Sienna

HWC: Indigo

M. Graham: Ultramarine Blue

Winsor & Newton: Hooker's Green • Permanent Alizarin Crimson • Prussian Blue • Scarlet Lake • Sepia

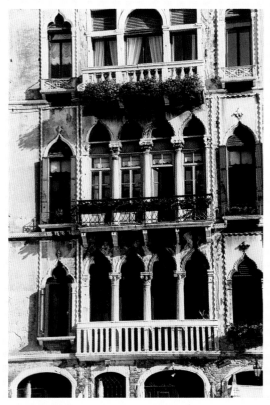

Reference Photo
This is an example of an imperfect reference photo. The distorted vertical lines, which are sloping inward, will have to be fixed. However, the photo provides valuable information on the architectural details, otherwise long forgotten.

Drawing
As you draw, correct the vertical and horizontal lines of the building's architectural elements that were distorted by the camera lens. Using a ruler makes drawing the lines easier. Develop the drawing's details after establishing the correct skeletal lines.

Planning Before You Paint Pays Off

There are many guidelines for creating a good composition. However, instinct may be a better guide to your compositions than all the guidelines and rules. Whichever works for you, put some thought and time into designing the composition at the beginning of the painting process. When you start with a good, solid composition, it is easier to create a wonderful painting.

Luckily, we live in a great technological era, one in which we can quickly capture anything with a snapshot to use later at our own convenience. Use the resources available to you wisely, and take advantage of tools such as digital cameras, computers and projectors to accomplish your painting goals.

1 Apply the First Undercoats

Prepare thinned Ultramarine Blue and Prussian Blue on a palette. Apply it over the entire surface with a 2½-inch (64mm) hake. The light blue creates a calm, soothing undercoat for this old, worn building. After it dries completely, prepare thinned Burnt Sienna on a different palette. Apply this color as an undercoat on several parts of the building, using a no. 10 round. Do not apply this color on the lighter columns, the arch window frames or the vertical architectural ornaments of the building.

2 Undercoat the Wall

Continue applying Burnt Sienna on the surface of the wall and the window frames with a no. 10 round. The columns of the first-floor balcony now appear too wide and clunky, so redraw them with thinner ones, adding columns as necessary to fill the width of the balcony.

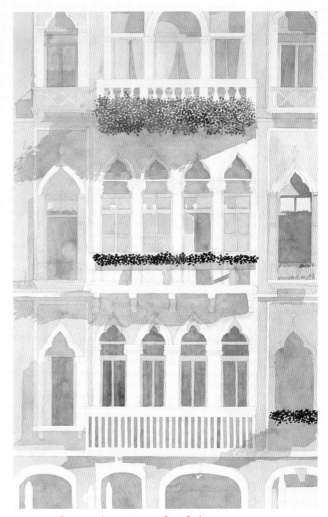

3 Undercoat the Glass

Using Ultramarine Blue and Prussian Blue, apply a light mixture on the glass of all the windows with a no. 10 round. At this stage, the elements of the building slowly develop, beginning to unify the entire painting.

4 Undercoat the Doors and Red Flowers

Continue adding the light blue undercoat to the remaining windows and doors on the bottom. Apply thinned Prussian Blue for the shadows with the same brush. At this point, the light values start to take shape, giving more definition to the picture. Next, as you begin to paint the flower boxes, cluster smaller dots on the top balcony and larger dots for the other two. Paint the dots for all three flower boxes with thinned Permanent Alizarin Crimson using an old no. 12 round without a well-pointed tip. Then, add more flower dots to all three flower boxes with Scarlet Lake.

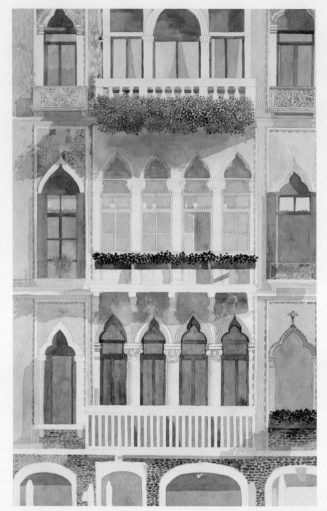
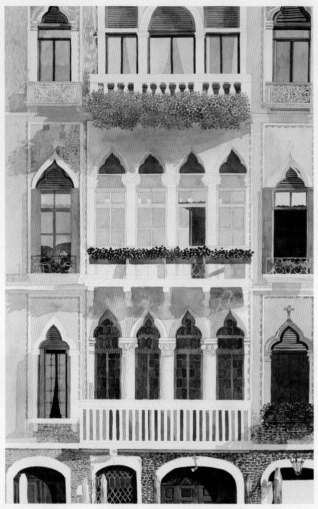

5 Glaze On Warm Color and Add Leaves

Apply a thinned mixture of Burnt Sienna and Permanent Alizarin Crimson on the window shutters and frames with a no. 10 round. Also, create the base of the bricks on the wall where the stucco has fallen off. For the leaves in the flower boxes, create green dots using Hooker's Green and the same brush in some of the spaces between the red dots. Use the same technique to paint additional green dots, but more extensively, for the greenery seen on the far left and far right of the middle floor.

6 Define the Dark Areas and the Bottom Doors

Mix a puddle of dark color on a palette with Indigo, Sepia and Permanent Alizarin Crimson. Apply it on the dark parts of all of the windows and the shadows that fall on the doors along the bottom of the painting. Use a no. 4 round for the window details and a no. 10 round for filling in the broad areas. Take care to paint around the lighter details, such as the middle floor's wrought-iron balcony and behind the greenery. Use thinned Hooker's Green to paint the doors on the bottom. Add enough of the dark mixture used above to make a dark green for painting the shadows on the doors.

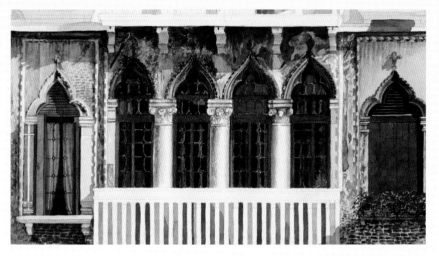

7 Deepen the Shadows

Mix thinned Indigo and Sepia for a cool black in an amount sufficient to complete the cool shadows. Unless otherwise noted, use nos. 6 and 8 rounds for this step, selecting a size appropriate for the area you are painting. Use this mixture to darken all of the shaded areas that are behind the window panes. Also use this mixture for the darkest parts of the shadows on the doorways on the bottom. Use a dry-brush technique to darken the shadows below the wrought-iron balcony.

Next, for a warm black, mix Permanent Alizarin Crimson, Indigo and Sepia, in an amount sufficient to complete the warm shadows. Use this mixture for the shadows on all of the architectural elements made of wood or stucco. Also use it for the shadows along and below the upper-right side of every arch on the top three levels. Use a no. 4 round for the tiny details, using dry-brush strokes to create a rough surface.

For the shadows that fall on bricks, use a mixture of Burnt Sienna and Permanent Alizarin Crimson.

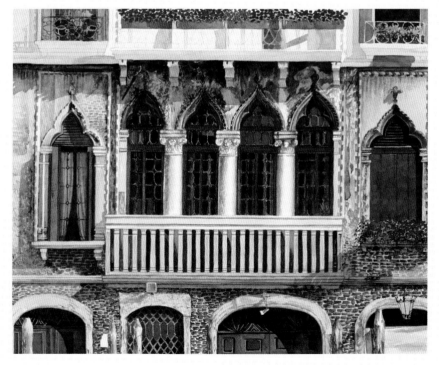

8 Add Details and Texture

Using the same mixtures and brushes as in the previous step, continue to define and finish the painting's dark shadows. For the lighter parts, such as the balcony and columns, apply highly thinned Burnt Sienna and Prussian Blue for a first light glaze. After it dries, use the same mixture to add texture. At this point, the bottom half of the painting may be done, depending on the amount of effort given to it.

9 Refine the Windows

Using a moderately thinned mixture of Ultramarine Blue and Prussian Blue, darken the windows that are reflecting the blue sky. On the top windows, with the same blue, define the curtains with a no. 4 round.

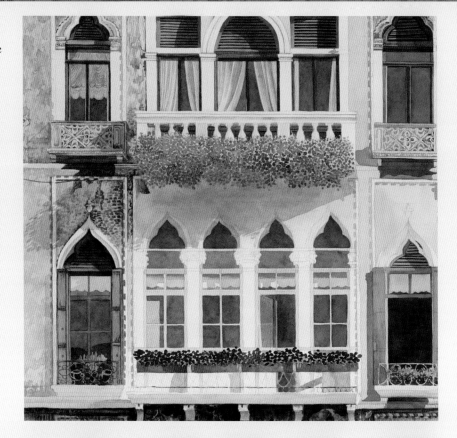

10 Finish the Details

Finish the dark details of the wall's texture and the windows' shadows with the several dark mixtures used in the previous steps. Alternate between them, using your judgment, based on the section of the painting at hand. Use a no. 8 round for glazing larger sections and a no. 4 round for dry-brush texturing.

Continue developing the flower box and flowers using the same dark mixture. Carefully apply dark color on the lighter areas adjacent to the red and green dots to create deeper values, but save the lighter red and green. Concentrate more dark dots on the bottom of the flowers and the box. Work on the shaded area of the wall under the box and shape the arches with the same color, using drybrush to create a rough surface. Use a thinned version of this dark mixture to glaze the Corinthian columns and the capitals with the same brush. Glaze Quinacridone Burnt Orange on the capitals and the wall as needed to bring out the redness. Instead of trying to finish the texture in one pass, apply several layers to attain deep, dark value.

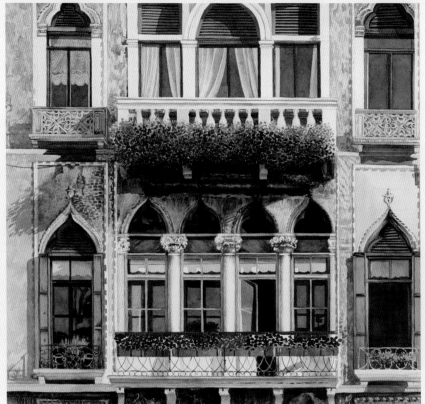

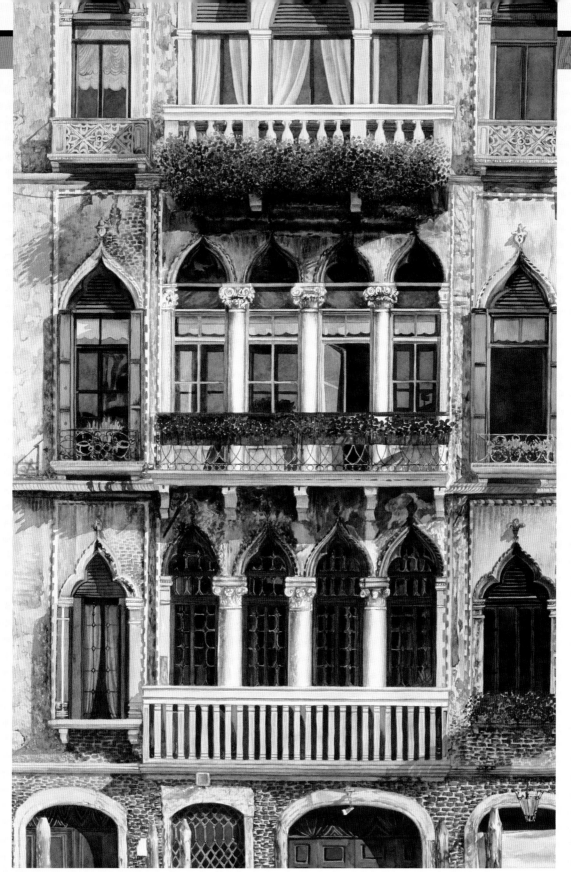

11 Evaluate and Adjust the Painting

Prop the painting against a wall and step back. Look at the painting while squinting to see if any part stands out as too light. If necessary, continue working on large or small areas to balance the overall painting until the results satisfy you. Yes, it is tedious work to complete so many small details, but the result is beautiful and pleasing!

Windows
Watercolor on Arches 200-lb. (425gsm) cold press
40" x 26" (102cm x 66cm)

Imitate Nature's Complements in Artificial Arrangements

In contrast to the complementary pairing of red and green, which occurs so often in nature, the orange and blue pair might appear somewhat artificial. Can you think of a single plant that comes together as orange and blue? However, in the natural environment, the backdrop of a blue sky complements many orange plants and flowers. Here, a lemon placed in a blue saucer-shaped glass bowl mimics the complementary combination of yellow-orange against a blue sky—an object from nature nestled in its manmade complement.

Materials

Arches 300-lb. (640gsm) cold press • masking fluid • nos. 8, 10 and 12 rounds

Watercolors

Daniel Smith: Quinacridone Burnt Orange • Quinacridone Violet

Da Vinci: Cadmium Yellow Medium

M. Graham: Ultramarine Blue

Stephen Quiller: Payne's Gray

Winsor & Newton: Aureolin • Permanent Alizarin Crimson • Prussian Blue

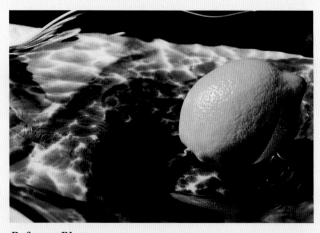

Reference Photo

Drawing
Draw the contour of the lemon and the shapes of the glass to guide the placement of compositional elements and design details as you paint.

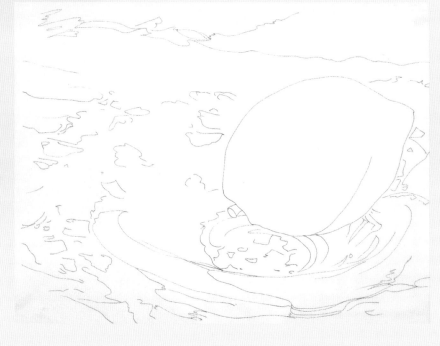

Juxtapose and Mix Complements for True Sparkle

Most artists know that visual energy and excitement is generated when two complementary colors are placed side by side. And, though you'll usually want to avoid mixing equal amounts of complementary colors—which makes muddy grays—you can make beautiful, rich blacks by mixing complementary colors. This option is preferable to using an ordinary, dull black pigment.

Both of these characteristic traits of opposite colors can be put to good use to create compelling, vibrant paintings.

1 Apply a Yellow Undercoat

Apply masking fluid on the lemon's highlights. After it dries, apply thinned Aureolin on the lemon and its reflection in the glass with a no. 12 round.

2 Add Yellow and Red Glazes

Apply a wet-on-wet glaze with Cadmium Yellow Medium and a mixture of Quinacridone Burnt Orange and Permanent Alizarin Crimson, using a no. 10 round for the yellow and a no. 12 round for the red mixture. Apply the yellow on the lighter left side of the lemon, immediately followed by the red mixture on the right side. Let this dry. Apply a mixture of Quinacridone Burnt Orange and Permanent Alizarin Crimson on the bottom reflection and the shadow of the lemon using a no. 10 round.

3 Begin the Background

Using Ultramarine Blue with nos. 8 and 10 rounds, apply blue in quasi-random circular shapes on the paper. Place the most intense and darkest shapes under the lemon and along the dish's inner ridge. Paint gradually lighter shapes toward the upper part of the paper, stretching out the light area along the upper-left corner.

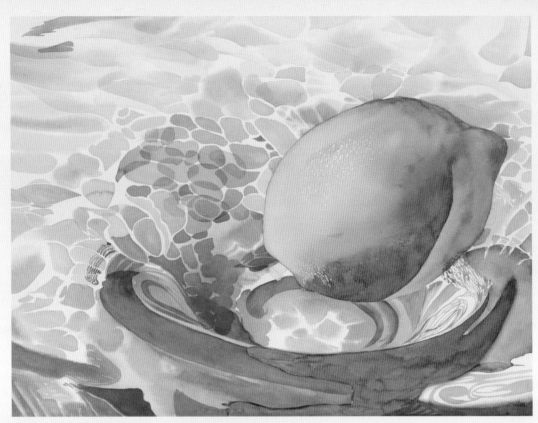

4 Develop the Background

Apply masking fluid to save the light under the lemon. Allow this to dry, then continue developing the background with the same brushes and a new mixture, adding Prussian Blue to the Ultramarine Blue for the slightly yellowish effect at the top of the picture. Glaze the circular shapes on dry parts of the paper to create the transparent effect.

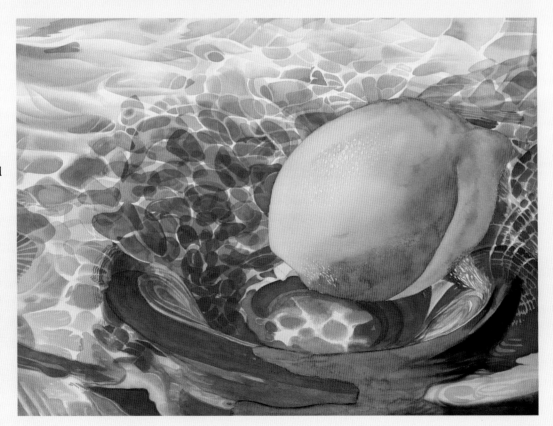

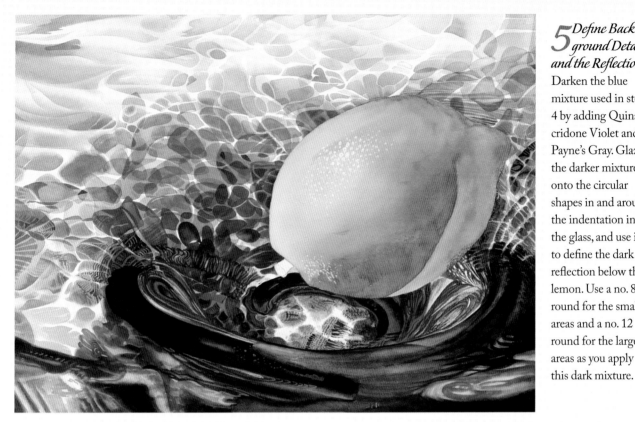

5 Define Background Details and the Reflection

Darken the blue mixture used in step 4 by adding Quinacridone Violet and Payne's Gray. Glaze the darker mixture onto the circular shapes in and around the indentation in the glass, and use it to define the dark reflection below the lemon. Use a no. 8 round for the smaller areas and a no. 12 round for the larger areas as you apply this dark mixture.

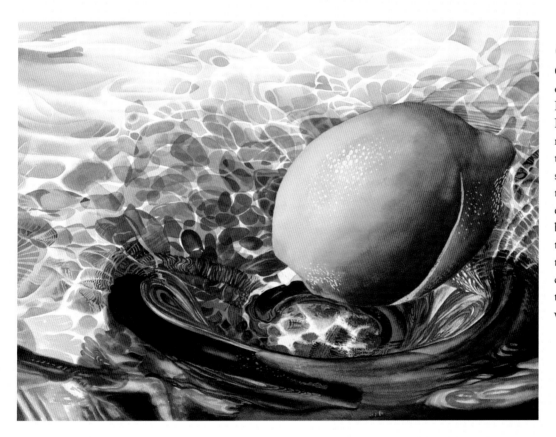

6 Define the Lemon

Glaze a mixture of Quinacridone Burnt Orange and Permanent Alizarin Crimson on the lemon's lighter shadow. Then, add to this mixture enough of the dark blue mixture from the previous step to produce the darkest shadow of the lemon; apply it with a no. 10 round.

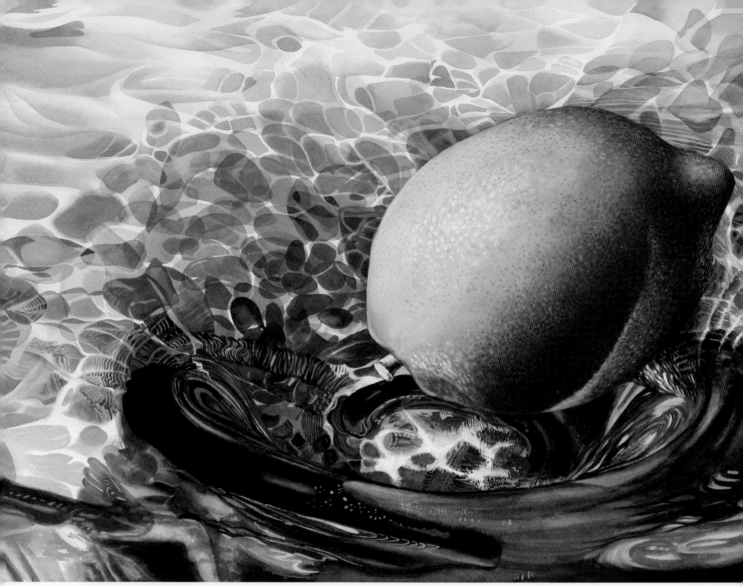

7 Finalize the Painting

Remove the masking fluid and soften any hard edges by scrubbing them with a stiff, damp old brush. Using all the colors from the previous steps, finish defining the lemon with a no. 8 round, giving it full form and adding details until you are satisfied. The yellow-orange and blue-violet complement each other to sparkle brilliantly!

Lemon and Blue
Watercolor on Arches 300-lb. (640gsm) cold press
22" x 30" (56cm x 76cm)

Get Close to Show a Different Side

I want to portray the quintessence of an elephant. The adjectives my nephew, Hae Seong, uses to describe an elephant are: humongous, gigantic, kind, slow, strong, gentle and smelly, but neither pretty nor ugly—and I agree! I like the gentleness, maybe just the calm look, of this particular elephant, so this composition will illustrate the creature's gentle side and size. Instead of painting an entire huge elephant, I concentrate on one small part: a closeup of its head. The rest of the body is up to the viewer's imagination. To make the composition showcase the special, unique and whimsical side of the elephant, I include a very small eye, many wrinkles, a smiling mouth and just a hint of its rolling trunk.

Materials

Arches 300-lb. (640gsm) cold press • India ink • masking fluid • nos. 4, 8 and 12 rounds • 2½-inch (64mm) hake • table salt

Watercolors

Daniel Smith: Quinacridone Burnt Orange

HWC: Indigo

Stephen Quiller: Gamboge

Winsor & Newton: Permanent Alizarin Crimson • Prussian Blue • Sepia

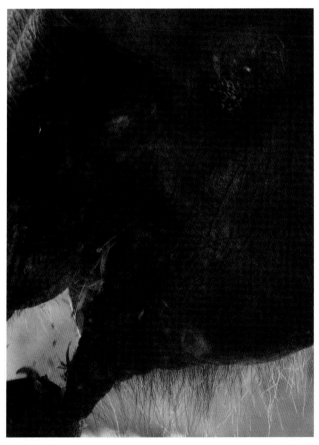

Reference Photo

Drawing

Enlargement Helps Eliminate the Unessential

To design a more interesting composition, first consider eliminating unnecessary elements from the scene. The easiest way to simplify a composition is to enlarge an image so that it extends beyond the boundaries of the picture. The enlarged feature or features emphasize shapes lost in a busier composition, creating eye movement that would not otherwise occur. The new relative size of the features alters their hierarchy of relative importance within the subject, and often makes them easier to paint!

The more extreme the closeup of a subject becomes, the more it creates an abstract form and extends your artistic repertoire. In other cases, a close-up view maintains the subject in its original form, but cropping secondary elements or the background creates a stronger center of interest. Of course, all compositional concepts apply when creating a design based on a closeup of your subject.

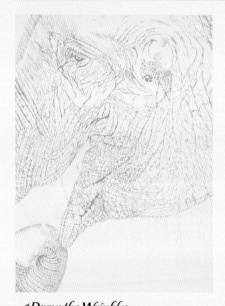

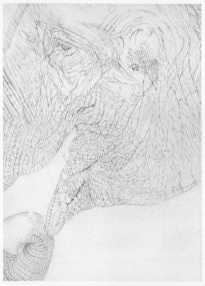

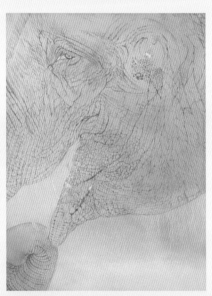

1 Draw the Wrinkles
Using India ink, draw wrinkles with a no. 4 round. This is a tedious undertaking, but certainly worth the effort. Taking advantage of the transparent nature of the watercolor paints in this demonstration, the permanent-ink wrinkles will show through and guide you until the finishing stage. Apply masking fluid on the fine hair under the elephant's chin and near its eye to save the lighter color.

2 Apply a Yellow Undercoat
Apply a wash of Gamboge on the elephant with a 2½-inch (64mm) hake. Sprinkle some salt on the bottom of the paper to slightly brighten up the pale yellow background. Let it dry.

3 Apply a Red Undercoat
Mix thinned Permanent Alizarin Crimson and Quinacridone Burnt Orange on your palette, then apply it on the entire surface with a 2½-inch (64mm) hake. Apply a little more of this red on the elephant than on the background. Sprinkle more salt on the same place on the bottom. Let it dry, then brush the salt off with your hand.

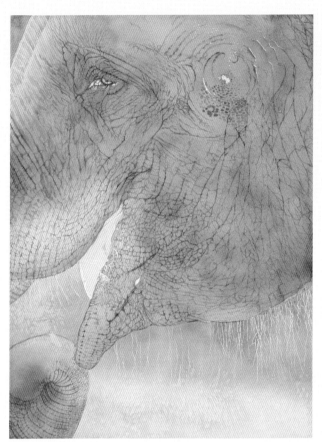

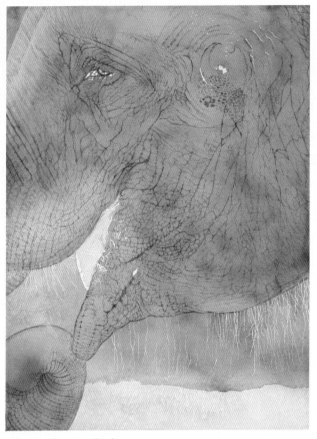

4 Deepen the Red Undercoat
Using a no. 12 round, apply a glaze to deepen the value on the elephant and the background sections of the painting with the same red mixture. Let it dry.

5 Apply a Cool Glaze
Apply thinned Prussian Blue to cool down the painting as follows. Apply blue with a 2½-inch (64mm) hake on the elephant. Allow the elephant to dry, and then glaze blue on the bottom of the background. Use a no. 12 round for better control in the smaller area along the bottom.

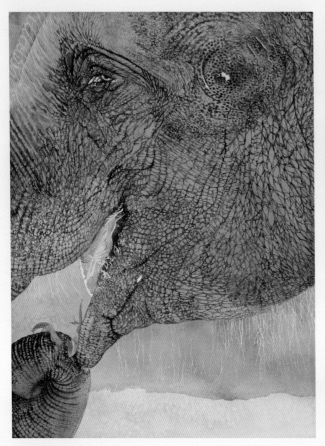

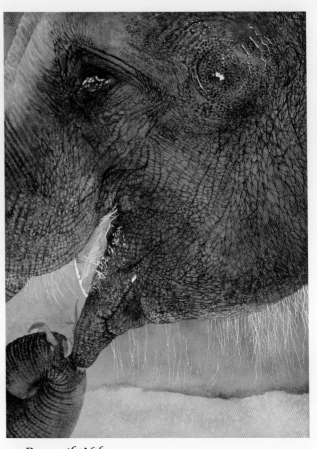

6 Define the Features

Using a mixture of Sepia, Prussian Blue, Indigo and Permanent Alizarin Crimson, define the wrinkles of the head with a no. 4 round. The undercoat washes become the color of the skin. Also, start to define the mouth and a few dry leaves with a mixture of Permanent Alizarin Crimson and Gamboge and a no. 4 round.

7 Deepen the Values

To deepen areas of the elephant's skin, use a no. 12 round to apply a mixture of Prussian Blue, Indigo and Sepia on the bluish area and a mixture of Permanent Alizarin Crimson and Gamboge on the warm reddish area. After the elephant dries, apply the reddish mixture on the background and then the bluish to intensify the values in these areas. Remove the masking fluid after the glaze dries.

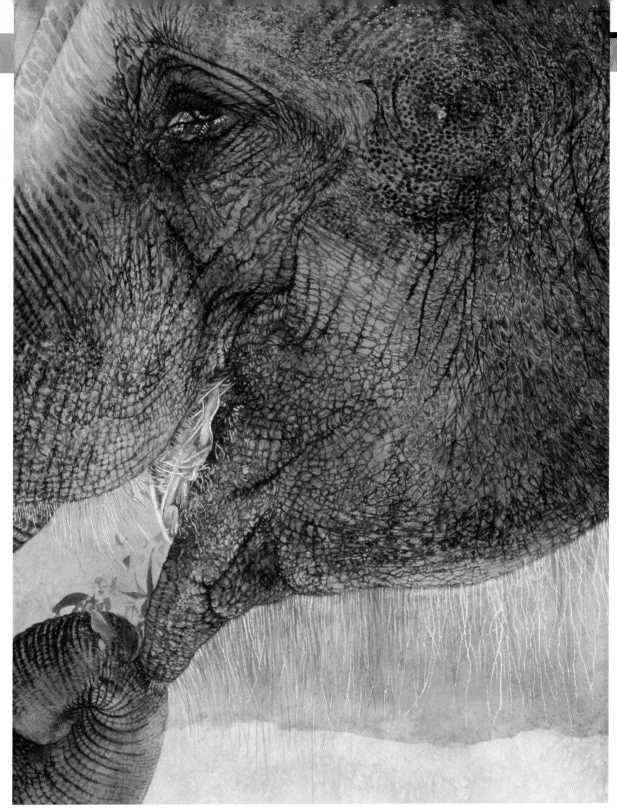

8 Add Details

Using the dark bluish mixtures from steps 6 and 7 and a no. 4 round, define the wrinkles of the eye area and around the mouth. Define the dried silage in the elephant's mouth using the reddish colors from previous steps. Where the masking fluid was, use a clean, wet no. 8 round to rub the area gently to loosen some pigment to cover up the white hair. After that dries, draw thin, dark hairs using the reddish color from the palette with a no. 4 round.

The closeup of the elephant's head, which fills up more than half of the picture, emphasizes the massive size of the animal.

However, reddish warm colors, the mischievously narrow eye and mouth, and the tip of the rolled trunk playfully coming in from the lower-left corner accentuate the gentle side of the elephant. The contagious smile of the elephant brings out the viewer's smile, too.

Gentle Giant
Watercolor and India ink on Arches 300-lb. (640gsm) cold press
30" x 22" (76cm x 56cm)

Spice Up the Colors in Cast Shadows

At noon on a hot, sunny day, the strong shadow cast on the ground directly beneath this neglected bicycle caught my attention. The play of the cast shadow brought out an interesting interaction between the bicycle and the light foreground. For additional interest, I used warm colors for the shadows, which provided a livelier approach to what normally would be a dull, dark, cool cast shadow.

Materials

Arches 300-lb. (640gsm) cold press • masking fluid • nos. 8, 10 and 12 rounds • no. 8 flat • 3½-inch (89mm) hake • stiff bristle brush

Watercolors

Daniel Smith: Quinacridone Burnt Orange

M. Graham: Ultramarine Blue

Stephen Quiller: Payne's Gray

Winsor & Newton: Aureolin • Permanent Alizarin Crimson • Permanent Magenta • Prussian Blue • Quinacridone Gold • Scarlet Lake • Sepia

Reference Photo

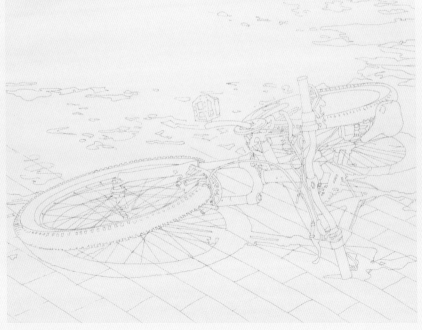

Drawing

Create Dynamic Cast Shadows

Bright, sunny days present opportunities to play with cast shadows and discover unexpectedly interesting combinations of ordinary, everyday subjects. Throughout the day, objects in space create continuously varying compositions as shadows constantly change. Some shadows are long and stretched, others are narrow and focused. Intense dark shadows in a painting create eye movement, depth, drama and—naturally—strong contrast. Remember that where shadows fall, shadows are not just dark and gray, but are darker-value versions of the colors of the surfaces on which they lie.

1 Apply a Yellow Undercoat
Apply a diluted mixture of Quinacridone Gold and Quinacridone Burnt Orange on the entire surface with a 3½-inch (89mm) hake. Apply any leftover paint on the top of the picture to deepen it. Let it dry.

2 Cool Down the Temperature With Blue
Using a thinned mixture of Prussian Blue and Ultramarine Blue, apply a layer on the entire surface with a 3½-inch (89mm) hake. Let it dry.

3 Save the Highlights
Apply masking fluid to save the bicycle's highlights. Let it dry. Then, with a 3½-inch (89mm) hake, apply a thinned mixture of Permanent Magenta and Ultramarine Blue on the entire surface to deepen the light value of the undercoat. Let it dry.

4 *Define the Shapes*
Draw the grid lines on the ground with a mixture of Quinacridone Burnt Orange and Sepia using a no. 8 round. With nos. 8 and 12 rounds, use thinned Payne's Gray to start defining the shapes of the bicycle, including the tires, seat and handlebars, and the background shadows. Be sure to leave glints of light among the background shadows for the sunlight coming through.

5 *Add Warm Layers*
Using a mixture of Quinacridone Burnt Orange and Permanent Alizarin Crimson, loosely apply a layer on the background with a no. 12 round. Also, apply Permanent Magenta, Aureolin and Scarlet Lake individually on the appropriate parts of the bicycle body, using the same brush.

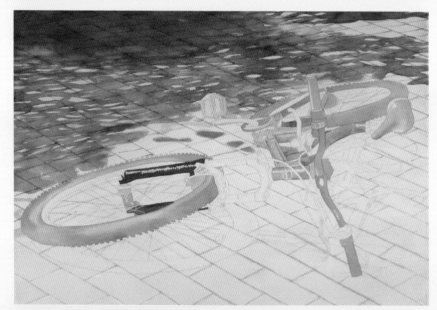

6 *Define the Cast Shadows*
Using a thicker mixture of Quinacridone Burnt Orange and Permanent Alizarin Crimson, start to define the front wheel's shadow with a no. 8 round. Continue defining the bike's cast shadow toward the back while thinning the pigment with water. Add a little touch of Quinacridone Gold to the back wheel's cast shadow. Thin the red mixture and apply it on the lighter spots of the background.

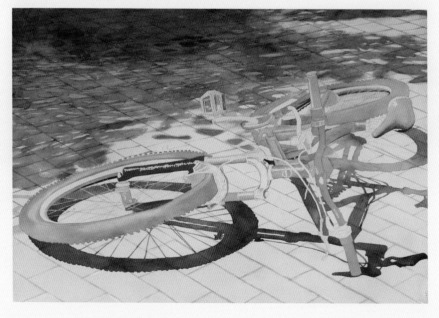

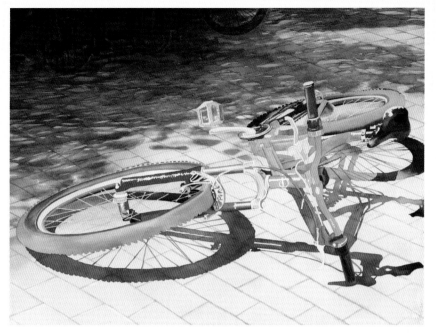

7 Deepen the Background

To create more depth in the background, use the colors from the previous steps to add the wall and several bicycles. Continue to apply the same warm colors on the background and darken it with a mixture of Payne's Gray, Permanent Alizarin Crimson and Prussian Blue, using nos. 8 and 10 rounds.

Remove the masking fluid. Begin developing the darkest details of the bicycle's tires, seat and handlebars by glazing mixtures of Payne's Gray, Prussian Blue and Permanent Alizarin Crimson with a no. 8 round, varying the concentration of each color depending on the specific detail. Apply a mixture of Permanent Alizarin Crimson and Quinacridone Burnt Orange on the cast shadows of the back wheel and handles. After this dries, deepen the shadows with a dark bluish mixture, using a no. 8 round.

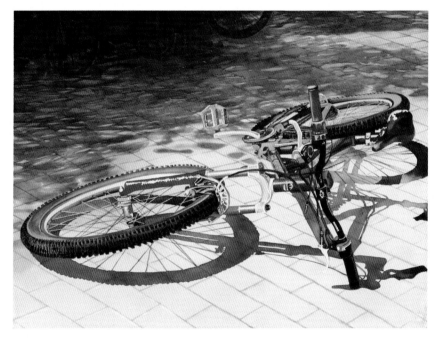

8 Define the Bicycle

Define the bicycle body using Permanent Magenta with a no. 8 round. Continue to glaze dark paint to finalize the overall details of the bicycle, including the spokes of the wheels. For the tire's details, use a no. 8 flat.

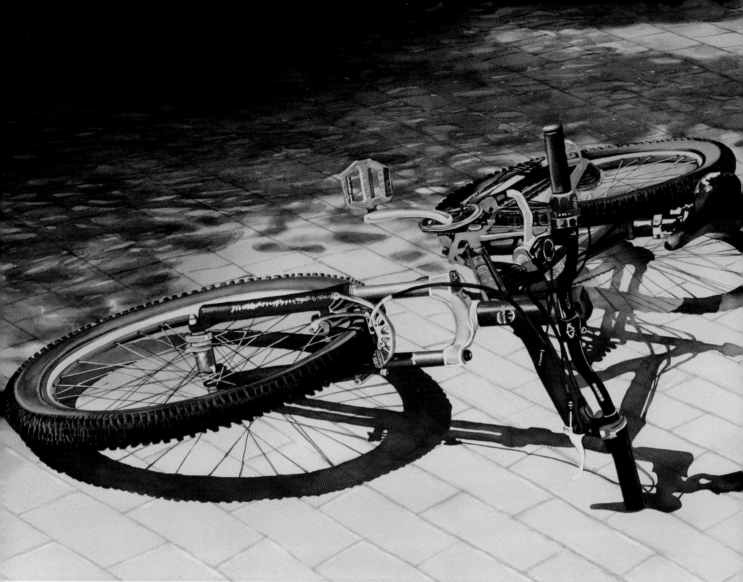

9 Finalize the Painting

Using a stiff bristle brush, soften and lighten the grid lines in the foreground. Also, deepen the value of the bicycle's shadow by glazing with a mixture of Permanent Alizarin Crimson and Payne's Gray, using a no. 8 round. With a no. 12 round, glaze the dark colors used in the previous steps on the background to make it dull and out of focus and to give it more depth. Prop the painting against a wall and stand back to see if anything stands out. If necessary, make corrections.

Left It Alone
Watercolor on Arches 300-lb. (640gsm) cold press
22" x 30" (56cm x 76cm)
Collection of Koch Industries, Inc. Wichita, Kansas

Place a Concrete Subject Against an Abstract Backdrop

Using an unusual element for the background can make a conventional foreground subject more appealing. In this demonstration, the swirling, freeform glass behind the sunflower creates a wide range of values and exaggerated, reflected colors, from delicate to bold. To add a mystical feeling, place graphic dragonflies in the background to hover over the sunflower.

Materials

Arches 300-lb. (640gsm) cold press • masking fluid • nos. 6, 8, 10 and 12 rounds • script liner • gold and silver powder • acrylic medium

Watercolors

M. Graham: Ultramarine Blue

Winsor & Newton: Cadmium Red • Hooker's Green • Payne's Gray • Permanent Alizarin Crimson • Prussian Blue • Quinacridone Magenta • Scarlet Lake • Sepia

Acrylics

Golden Fluid: Hansa Yellow Medium

Reference Photo

Drawing

Successfully Combining Realism and Abstraction

There may be many reasons why I choose to paint a particular subject. My interest in realism and detail is always present in my paintings; often with the exaggeration of one or more artistic elements, such as color or size. My typical subject is a familiar object from my surroundings. Usually, beautiful images or strong colors draw my attention as I work to express a mood and craft interesting compositions. Sometimes I incorporate vague or imaginary elements into more realistic images to expand the possibilities for pleasing visual effects.

1 Apply Masking and Powder With Acrylic Medium
Apply masking fluid with the sharply angled tip of a brush handle to draw thin lines, saving as many of the highlights and reflections in the glass as possible and only on the dragonflies in the upper left and right corners. Then, using a script liner, apply gold and silver powder mixed with acrylic medium to the remaining dragonflies. The effect will be similar to that of masking fluid, preventing the watercolors from absorbing into the paper, but this will remain on the paper rather than peel off.

2 Apply a Yellow Acrylic Undercoat
For a permanent, solid yellow undercoat, use liquid acrylic instead of watercolor. Apply Hansa Yellow Medium fluid acrylic on the flower, some of the dragonflies and parts of the background with a no. 12 round.

3 Apply the Background Undercoat
Using a mixture of Payne's Gray and Prussian Blue, apply the dark color on the background and the dark parts of the glass with a no. 12 round. Apply masking fluid to save the lighter spots on the flower's central disk.

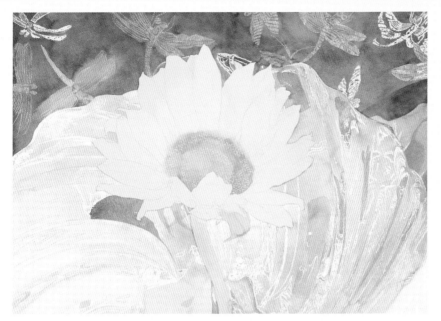

4 Apply a Red Undercoat
Apply thinned Cadmium Red on the flower's central disk and the entire surface—except where the yellow flower petals will be—using a no. 12 round.

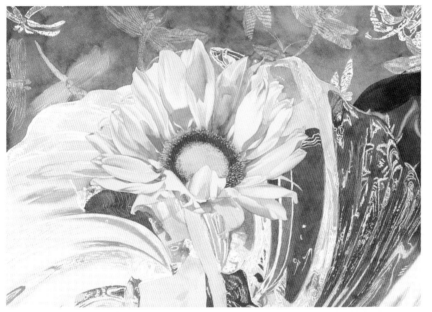

5 Glaze With Red
Using a mixture of Scarlet Lake and Permanent Alizarin Crimson, gently glaze the sunflower petals and center with a no. 8 round. Using a no. 12 round, evenly apply the same color on the red fabric's reflection in the glass to the right of the flower, and gently glaze to the left of the flower.

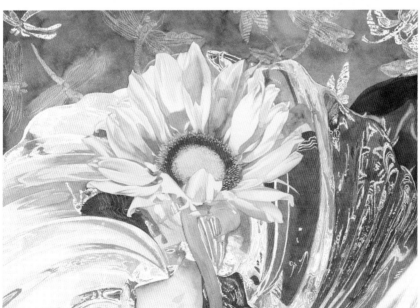

6 Glaze With Green
Lightly and sparingly, use Hooker's Green and a no. 8 round to glaze the stem, flower center, dragonflies and reflections around the glass.

7 Glaze With Blue

On the glass reflections, glaze Prussian Blue with a no. 8 round. The blue hue should be apparent in the lighter spots. On top of the red, however, the blue simply darkens the red. Lightly glaze blue on the disk of the flower, too, as well as the flower stem and leaves.

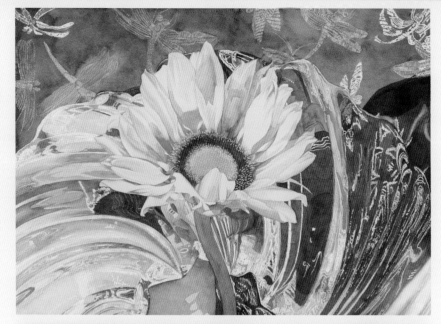

8 Darken the Red Fabric and Background

Glaze a mixture of Scarlet Lake and Permanent Alizarin Crimson to deepen the red fabric reflections in the glass with a no. 8 round. For the background, premix Permanent Alizarin Crimson, Sepia and Prussian Blue to make a black color. Apply it on the background with a fully loaded no. 12 round for a fast application. Apply the dark mixture over the dragonflies, too, instead of painting around them.

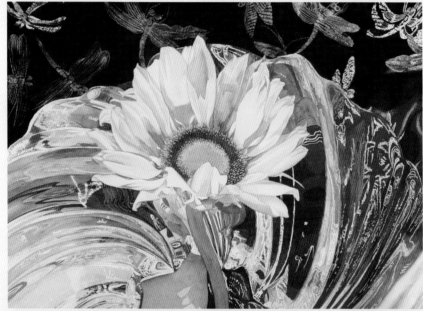

9 Define the Reflections

Glaze with the dark mixture used in the background to define the reflections on the glass, using nos. 6 and 10 rounds. Apply other red, blue or yellow colors to the glass to deepen the reflections in these hues, as needed.

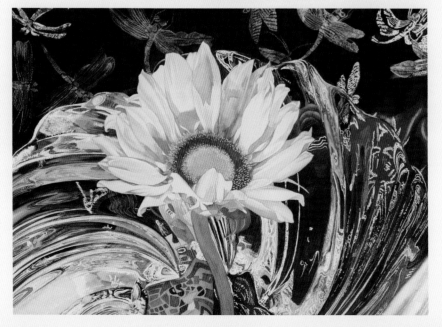

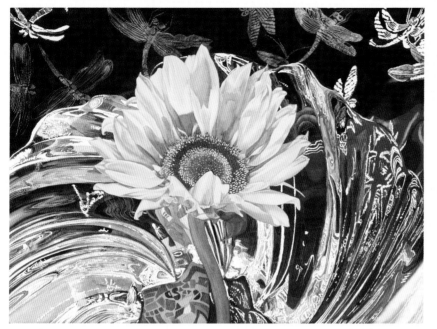

10 *Remove the Masking Fluid*
Glaze a mixture of Permanent Alizarin Crimson and Scarlet Lake on the sunflower disk, stem and small leaves with a no. 8 round. After it dries, remove the masking fluid from the entire painting. Use a dry hand to inspect the entire surface for sticky spots to make sure you've removed all the masking. The stark appearance of the unmasked white now stands out too much, breaking the rhythm of the painting.

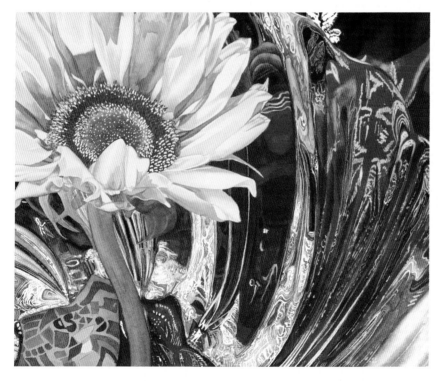

11 *Finish the Glass Details*
Using all the colors from previous steps—the red, yellow and black mixtures—finish defining the glass with a no. 6 round. Draw clean, sharp lines of the surrounding colors to create thin lines of reflection in the glass. Glaze one or two colors on some areas and lines to darken their values and to give the glass the illusion of depth.

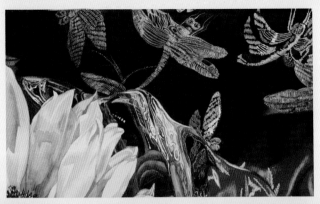

12 Define the Dragonflies

For the dragonflies on the background, lift dark pigments off the metallic drawings with any size clean, wet brush. The dark pigment will lift off easily because the medium surrounding the gold powder doesn't accept a stain. Then, using a no. 8 round, gently apply a purple mixture of Ultramarine Blue and Quinacridone Magenta on the white dragonflies in the upper right and left corners. Then, glaze a reddish mixture leftover from step 10 on the middle dragonflies to reflect the surrounding colors.

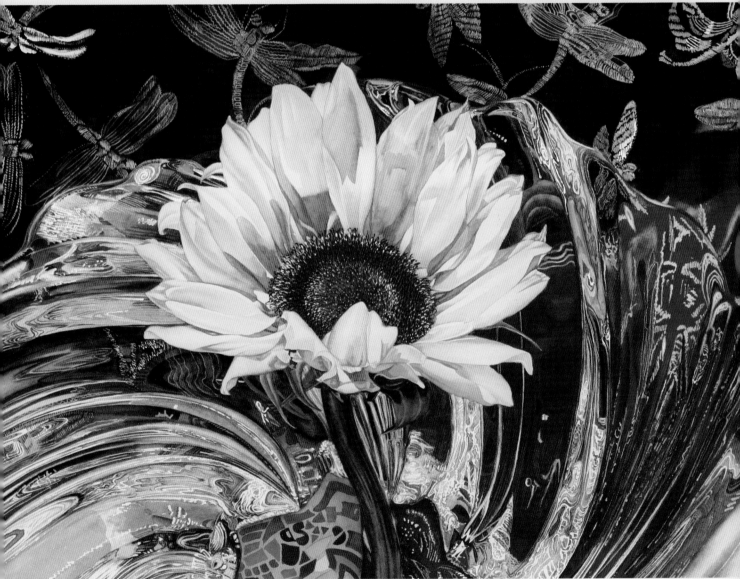

13 Finalize the Painting

Using a no. 6 round, draw dark dots on the flower disk, and glaze to define the stem and calyx with the mixed black used in step 8. Squint to see whether anything pops out, disturbing the harmony of the painting. Make adjustments as needed.

In this demo, the sunflower in the center of the painting remains realistic, but the fanned-out curvature of the glass distorts and reflects the dramatic red fabric. The dark background with its flying dragonflies adds an odd and intangible—yet still enticing—feeling to the composition.

Sunflower Dream
Watercolor, acrylic and metallic powder on Arches
300-lb. (640gsm) cold press
22" x 30" (56cm x 76cm)

Stylize to Enhance a Realistic Subject

The sheer size of an old oak tree makes it impressive, magnificent and majestic. It is easy to imagine that this particularly curvaceous tree's long, dark, tangled limbs are posing for yoga meditation. Looking up at the lines that the considerable branches create against the gray-green leaves evokes a profound feeling of awe at nature's beauty and power. In addition to its grand appearance, the massive size of the aged oak lends much needed shade, especially to those enduring the long, dry, hot summers of Texas. I want to combine this image from my backyard with a large full moon to break up the background of bare branches.

Materials

Arches 200-lb. (425gsm) cold press • masking fluid • nos. 4, 8, 10 and 16 rounds

Watercolors

HWC: Permanent Yellow Lemon

Winsor & Newton: Cadmium Red • Hooker's Green • Payne's Gray • Permanent Alizarin Crimson • Prussian Blue • Sepia • Winsor Blue (Red Shade)

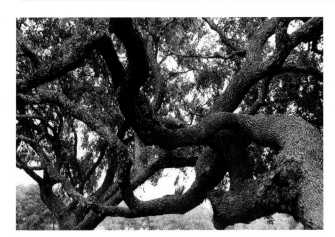

Reference Photo

Drawing

Playful Patterns Add Exciting Embellishment

Incorporating a stylized motif or pattern into your painting can be exciting and fun! Playful designs or exaggerated, bold colors offer more opportunities to stretch your imagination without letting go of realism entirely.

First, design a subject with a strong foundational composition; then, add some imaginative designs, favorite doodles or classic patterns to give a spark to the overall appearance.

1 Apply Masking and Undercoat the Tree
Apply thin masking fluid lines on the outlines of the tree branches and the highlights on the tree trunk. After it dries, apply thinned Winsor Blue (Red Shade) with a no. 16 round. The masking fluid makes the highlights visible.

2 Add Little Stylized Branches
To make the composition more eye-catching, develop additional small, stylized branches on the left side of the tree, creating an interesting abstraction within the realistic painting. Then apply thinned Winsor Blue (Red Shade) with a no. 10 round. Use your instinct and judgment to create the design. The upper right of the painting is intentionally less busy, allowing the viewer's eyes to relax there.

3 Apply Yellow
Apply Permanent Yellow Lemon on the background, section by section, with a no. 10 round. Apply the leftover blue paint on the tree branches as far as it will go.

4 Apply Red
Mix Cadmium Red and a small amount of Permanent Alizarin Crimson on a separate palette. Using a no. 10 round, apply the red mixture on the moon, located at the top of the painting and a little to the right. Also apply this mixture at various points around the painting to encourage eye movement.

5 Add Orange
Add Permanent Yellow Lemon to the red mixture to make an orange mixture. Apply this orange along the bottom and on the right side, as well as on various points around the painting, with a no. 10 round. At this stage, most of the paper is filled with orange and the primary colors: blue, yellow and red.

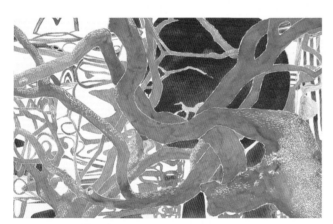

6 Deepen the Blue
Thin Winsor Blue (Red Shade) on the palette but leave it thicker than for the first application. Apply it on the thinner branches with a no. 10 round, then use a no. 16 round for the thicker branches for a faster, easier application. The stronger blue complements the other colors to improve the harmony of the whole painting.

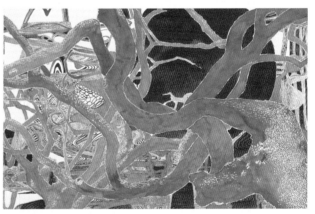

7 Decorate the Background With a Motif
Make a red mixture of Permanent Alizarin Crimson and Cadmium Red. Use it to start decorating the background with any motif that comes to mind and appeals to you. Use a no. 4 round for a fine texture. Add dots, lines and doodles to fill up substantial sections of the yellow and orange areas, but not the red moon.

8 Darken and Define the Branches

Using Permanent Alizarin Crimson, Payne's Gray, Prussian Blue and Sepia, mix a dark bluish black for darkening the branches. Using this thinned mixture, fully loaded into a no. 10 round, glaze the bigger branches, then gently feather it out with a no. 16 round. Begin defining the bark on the small branches with the tip of a no. 8 round.

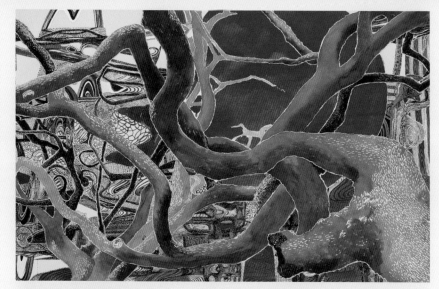

9 Detail the Branches

Using small brushstrokes with a no. 8 round, define the light areas of the branches with the same bluish black mixture from the previous step. On the dark side of the branches, apply more paint using dense strokes. Use less on the lighter side of the tree branches to develop three-dimensional roundness.

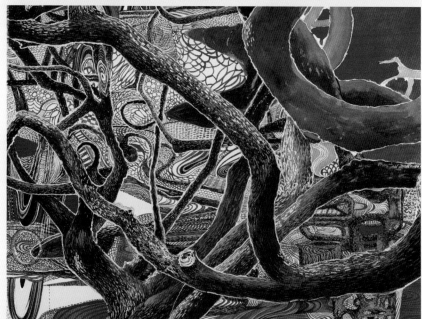

10 Finish the Branches and Remove the Masking

Complete the branches with the same paints and brushes. After finishing these details, remove the masking fluid. The stark white lines are very strong, standing out so much that they create an obvious distraction.

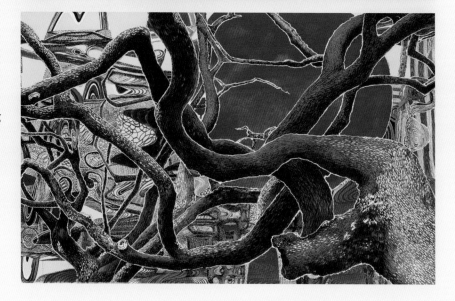

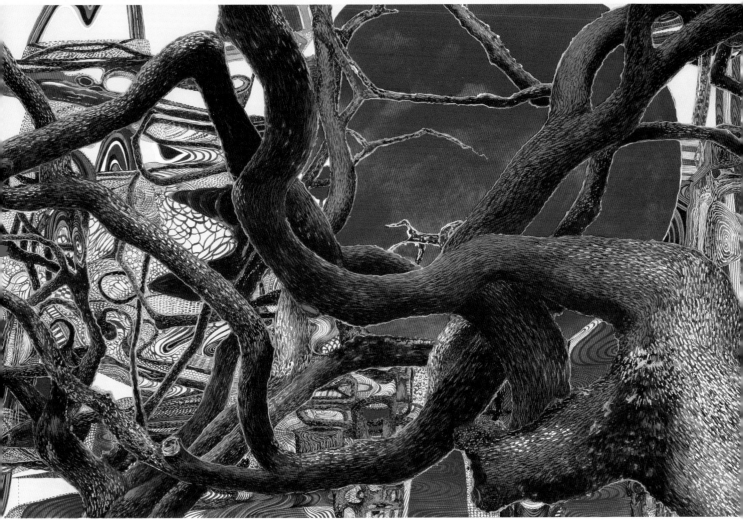

11 Tone Down the Whites

To deemphasize the white lines created by removing the masking, apply Hooker's Green on them with a no. 8 round, darkening their value. The green naturally bridges yellow and blue. Use thinned Winsor Blue (Red Shade) on the white highlights in the bark areas, leaving several for the spot highlight effect. Leave most of the central highlights on the tree trunk, but apply blue on highlights along both sides to give it three-dimensional form.

The simple tree branches and the moon visible from my backyard inspired me to transform the paper into a unique abstraction. Within the context of stylized form and motif, the tree, in a disorganized tangle, and the moon, simple and well-ordered, provide a center of interest, a force within the composition to grab the viewer's attention.

Urban Jungle
Watercolor on Arches 200-lb. (425gsm) cold press
25" x 39" (64cm x 99cm)

Convey Man and Nature's Coexistence

I found the unexpectedly beautiful forest greenery in Alaska refreshing and charming. In this setting, it isn't the majestic awe of a snowy mountaintop or some triumph of manmade architecture that attracts me, but it's this small corner of the shore and the simple, peaceful way of life found there. The shoreline scene, with the endless forest towering behind it, reminds me of man's inevitably humble coexistence with nature.

Materials

Arches 140-lb. (300gsm) cold press • masking fluid • nos. 10 and 16 rounds • 2½-inch (64mm) hake • table salt • old chopped brush

Watercolors

HWC: Indigo

Michael Wilcox: Burnt Sienna

Winsor & Newton: Hooker's Green • Permanent Alizarin Crimson • Prussian Blue • Sepia

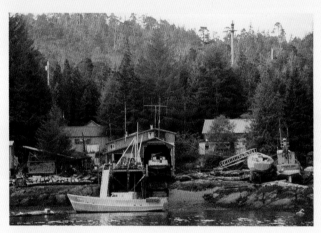

Reference Photo

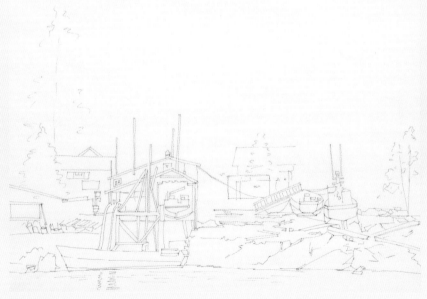

Drawing

Make a Good Impression Rather Than Sweating the Details

Although I don't paint landscape scenes regularly and have had fewer opportunities to explore multiple approaches for painting them, the stages of painting landscapes are essentially the same as for any other representational painting: start with a line drawing, followed by washing, glazing and detailing. Working in stages will give you time to think ahead and plan the next step.

There are differences, however, when painting landscapes. The previous demonstrations included tight, detailed drawings and controlled brushstrokes to portray subjects realistically, often in close-up. To create a realistic landscape painting, loose, sometimes random brushstrokes may be sufficient. Suggestions of leaves, rocks and sky, made with minimal brushstrokes, can mingle and harmonize to create the perfect backdrop for a scene. In landscape scenes it is often unnecessary to belabor details such as the veins of leaves, the cracks of rocks or the precise shadows of every cloud. Just the impression is enough!

1 Apply Masking and Pale Washes

Apply masking fluid to save the light areas on the boats, house structures, unused lumber and water. After it dries, apply very pale Prussian Blue on the water. To create the faraway mountains, draw semicircular shapes using the same pale blue with a no. 16 round, and feather out the paint at the bottom of the mountains. Sprinkle on some salt to further soften the mountains. Let this dry completely, then brush off the salt with your hand.

2 Start the Fir Trees

Draw the small and very light trees on top of the mountains with very thin mixture of Prussian Blue and Indigo, using an old chopped brush. With a tapping motion, start each tree with a point on the top and gradually work downward to form a triangular shape. Feather each out at the bottom with clean water to leave no hard lines. Dilute the mixture sporadically to avoid flat-looking trees.

Continue drawing each tree to fill the top across the paper. To give definition to the trees, draw each one separately on dry paper, then move away from the wet, freshly finished tree to avoid smearing or smudging it.

3 Add More Fir Trees

In the same manner as the previous step, add more layers of trees to fill up the background mountain area, slowly adding in some thinned Burnt Sienna for a brownish color to vary the color of the trees. Keep the values very light to give the area depth. After this dries, wash a thinned version of this mixture across the area under the trees with a no. 16 round and sprinkle on some salt to break up the smooth surface. Let this dry completely, then brush off the salt with your hand. You can now see where the masking fluid was applied.

4 Connect Areas With Washes

If, as in this case, the previous blue wash doesn't turn out as strong as it needs to be, add separate washes of the Prussian Blue/Indigo/Burnt Sienna mix and Burnt Sienna alone to integrate the sky, mountain and foreground. Wet the entire surface with clean water using a 2½-inch (64mm) hake. Then drop the blue mixture, somewhat randomly, to intensify some of the areas, letting the pigment spread out freely. Apply Burnt Sienna on the ground area at the same time. Sprinkle salt on randomly to break up the smooth surface. Let it dry completely, then brush off the salt with your hand.

5 Develop the Middle-Ground Trees

Before developing the trees, apply masking fluid to the lighter trees next to the buildings to save the existing color as a highlight. After it dries, start to develop the darker fir trees behind the building with an old chopped brush. Add Hooker's Green to the existing mixture of Prussian Blue, Indigo and Burnt Sienna to mix a darker green. Paint the trees one by one, diluting the mixture sporadically to avoid flat-looking ones.

6 Fill In More Trees

Fill up the middle ground with fir trees. Continue painting each tree on dry paper to give them definition. The lighter, less-descript areas of the trees create the appearance of a misty fog that suggests early morning.

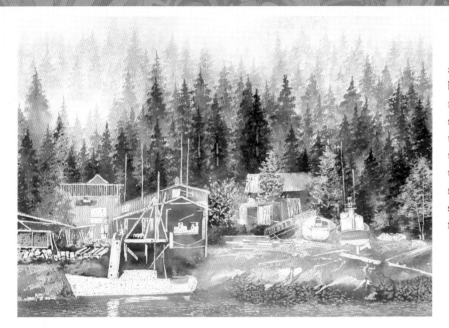

7 Develop the Foreground

Apply a mixture of Burnt Sienna and Permanent Alizarin Crimson on the buildings and the ground with a no. 10 round. Inside of the buildings, apply the same mixture used in the previous steps to paint the darker trees. Add Sepia to the mixture to create a warmer dark for the shoreline, and sprinkle salt on it for more texture. After it dries, brush off the salt before developing the details of the foreground.

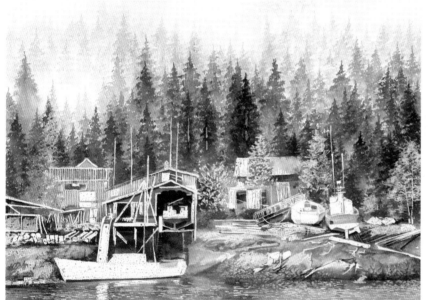

8 Develop the Dark Shadows

Alternating various mixtures of Permanent Alizarin Crimson, Prussian Blue, Indigo, Hooker's Green and Sepia, develop the dark shadows of the buildings and shape the shoreline, water and the small dark details of the foreground with a no. 10 round. Use darker combinations of the colors for the darker areas.

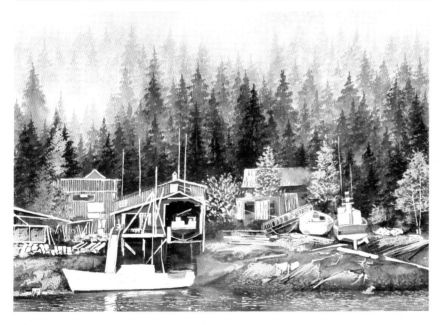

9 Remove the Masking

After removing the masking fluid, the stark white stands out too much. These areas need shadows and a light glaze to tone them down and allow them to harmonize with their surroundings.

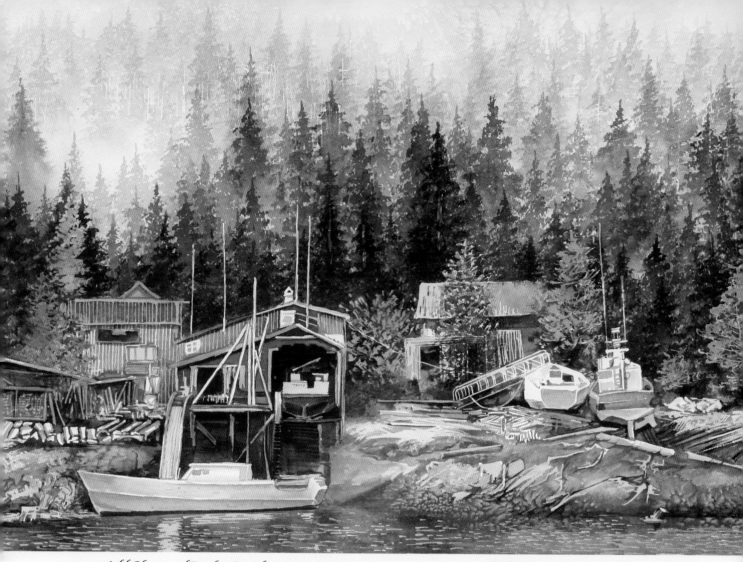

10 Add Glazes and Finalize Details

Glaze the lighter parts of the buildings and water with thinned pigments using the colors already on the palette. Also, define the boat by glazing the same colors with a no. 10 round. Use darker mixtures to define the little details of the buildings and ground as needed. After removing the masking fluid, few details are necessary on these highlight areas. If needed, adding a touch of dark color creates just enough detail.

Daybreak
Watercolor on Arches 140-lb. (300gsm) cold press
20" x 28" (51cm x 71cm)

Recall Vivid Memories With Vivid Colors

When I visit the Japanese Garden in the Fort Worth Botanic Garden, I'm always reminded of the landscape of my hometown in Korea—on a smaller scale, but delicate and pretty. The Japanese Garden's features—narrow trails, pine trees, maple trees and small rocks—all play a part in making the surroundings appear natural. Reminiscent of the beautiful scenes I took for granted when I was young, they always bring a smile when I visit, especially in autumn; it's like a trip home in less than thirty minutes! These memories and the emotions they stir inspire me to paint the colorful autumn gardens with bright, brilliant colors.

Materials

Arches 300-lb. (640gsm) cold press • masking fluid • nos. 4, 8, 10, 12 and 16 rounds • 2½-inch (64mm) and 3½-inch (89mm) hakes • table salt • old chopped brush • spray bottle

Watercolors

Daniel Smith: Quinacridone Sienna • Quinacridone Violet

Da Vinci: Cadmium Yellow Medium

Winsor & Newton: Cadmium Red • Hooker's Green • Sepia • Titanium White • Winsor Blue (Red Shade)

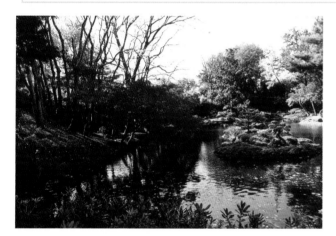

Reference Photo

Drawing

Make a rough, simple line drawing as a guideline for the shape and placement of the compositional elements.

1 Apply Masking Fluid

Start with an extensive application of masking fluid on the water's highlights, the leaves, the trees and the crane. Apply masking wherever the painting will benefit from lighter values.

2 Apply the First Washes

Wet the entire surface with clean water using your larger hake. Then, apply highly thinned Winsor Blue (Red Shade) on the sky and water areas with your smaller hake. Using the same brush, apply a thinned mixture of Cadmium Yellow Medium and Quinacridone Sienna on the leaves with a fully loaded no. 16 round. Let the colors mingle freely. Sprinkle some salt on the surface, anywhere needed to create texture. Let this dry then remove the salt with your hand.

3 Add Glazes for the Leaves and Reflections

Alternating Cadmium Red and Cadmium Yellow Medium, apply red and yellow on the leaves' reflections in the water with a no. 12 round, feathering out the colors after cleaning the brush to reduce hard edges. With an old chopped brush, randomly apply Cadmium Red for the red leaves in the maple trees. Apply a thinned bluish mixture of Quinacridone Violet and Winsor Blue (Red Shade) on the bottom half of the water, and drop thicker paint on the lower left, stepping back now and then to see how the color interacts with the surroundings.

4 Add More Red

Using Cadmium Red and Quinacridone Sienna, continue working on the reddish leaves by tapping on the paint with an old chopped brush. Extend the bottom bush toward the right with the same brush. Glaze the same reddish mixture on the water reflection. After it dries, apply the bluish mixture from step 3 to the bottom right corner with a no. 12 round. With the thinned bluish mixture, farther back but close to the center, create the pale tree using the old chopped brush.

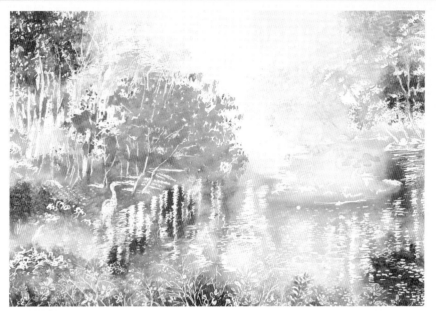

5 Add Blue

Using thinned Winsor Blue (Red Shade) and Quinacridone Violet with a no. 16 round, gently glaze the water and the sky. Sprinkle some salt on this blue while it is still wet to create a random texture.

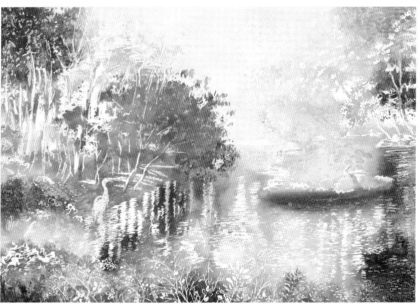

6 Remove the Masking Fluid

Remove the masking fluid everywhere except from the crane, its reflection and the trees on the small island on the right. With a no. 10 round and using Cadmium Red and Cadmium Yellow Medium on the palette, sometimes mixed and other times separately, start to paint over the white spots where the masking was. Add Sepia to the palette for a wet-on-wet application on the small island.

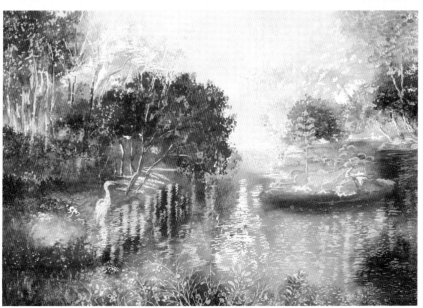

7 Develop the Shadowed Areas

Glaze thinned Winsor Blue (Red Shade) and Quinacridone Violet on the bottom half of the painting, primarily on the water, with your smaller hake. Apply Cadmium Red for the bright red leaves and thinned Winsor Blue (Red Shade) to create the shadowed areas of the leaves, all with a homemade chopped brush to avoid an application that appears flat. As you complete each section, sprinkle some salt on it before it dries to create more texture. After the painting's surface is completely dry, brush off the salt.

8 *Apply a Calming Green Wash*
Rather than use a brush, which would disturb the undercoat, spray a mist of clean water to wet the entire surface. Then, using your smaller hake, gently wash thinned Hooker's Green on the entire surface, except for the sky area, to calm the overall appearance. This process relaxes and softens the painting by allowing the existing colors to bleed together slightly.

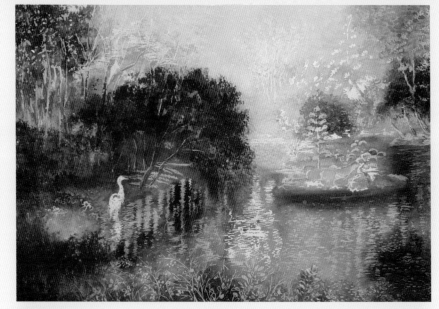

9 *Work on the Water Details*
Use nos. 4 and 8 rounds and existing colors on the palette to start defining the details of the water generally, and the reflections specifically. Continuously switch colors and brushes to accommodate the ever-differing reflections of autumn colors. Be free and have fun creating colorful water! Use some of the same dark colors to develop the tree trunks and leaves.

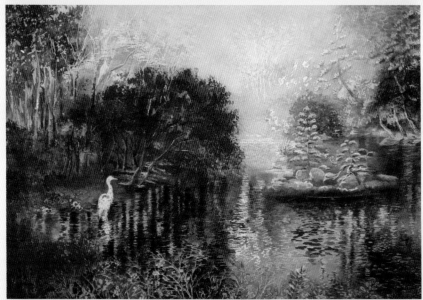

10 *Continue Defining the Trees*
Use the same brushes and colors to continue defining the leaves and tree trunks. Use thinned paints to lightly layer over the existing leaves and the trees to avoid creating too many dark details. Using very thinned reddish color and a touch of yellow from your palette, create very pale trees in the center distance. Develop the water in the distant background with a thin wash of the darker colors on your palette. Remove the masking fluid from the bird.

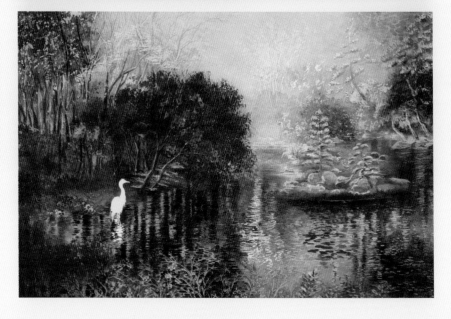

11 Fine-Tune the Details

Finish the blue crane with a mixture of Winsor Blue (Red Shade) and Quinacridone Violet, using a no. 4 round. Use Cadmium Yellow Medium for the beak. Correct the shape of the bird by adding feathers, using Titanium White to draw thin feathers. Glaze diluted blue over the light reflection in the center of the pond from the rear forward to draw less attention to it.

After studying the painting, the red maple leaves in the center seemed too dominant compared to their surroundings. The tree leaning toward the center further accentuated my discomfort with that area. To solve this problem, I lifted off red pigment from the bottom of the leaves and created a reflection with a dark bluish mixture using a no. 8 round. I lightened the edges of the red leaves by lifting off pigment first, then applying Titanium White randomly to bring out the light. This invites the viewer's eye to travel around the painting rather than stay fixed on the red maple leaves in the center.

To finish the painting, use a no. 4 round to apply the leftover dark colors from the palette to the interior of the red maple trees, giving them more depth.

Visitor in Garden
Watercolor on Arches 300-lb. (640gsm) cold press
20" x 28" (51cm x 71cm)

Evoke a Serene Mood With Muted Colors and Subtle Textures

How different it is to walk through the once lush, green forest when the trees are naked, the rocks are bare, and the stream is winding slowly through the snow. The grayness and dearth of colors create an atmosphere more like a sacred sanctuary than an arcade of nature. Walking along such a path beside a stream induces an aura of tranquility and serenity that I want to convey to the viewer of this painting.

Materials

Arches 140-lb. (300gsm) cold press • masking fluid • nos. 4, 10 and 16 rounds • 3½-inch (89mm) and 2½-inch (64mm) hakes • plastic wrap • table salt

Watercolors

Daniel Smith: Quinacridone Violet

HWC: Indigo

Winsor & Newton: Cadmium Red • Sepia • Winsor Blue (Red Shade)

Reference Photo

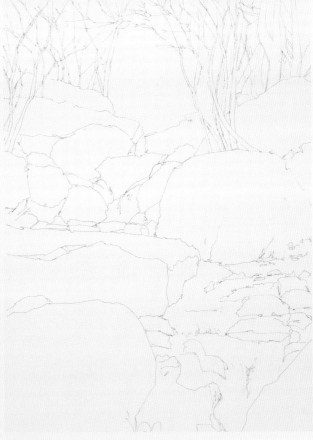

Drawing
Carefully draw the outlines of the rocks to show perspective and indicate how the water flows between the rocks. Also, draw trees if you want for the later steps.

1 Apply Masking Fluid

Apply masking fluid extensively on the water and rocks to save the highlights. Instead of cleanly and neatly applying it, use more erratic and uneven lines to create random texture. If you have any masking fluid left over, instead of returning it to its original container, sprinkle it randomly on the surface.

2 Apply the First Washes

Prepare thinned Winsor Blue (Red Shade) and Quinacridone Violet on separate palettes. Wet the paper with your larger hake, then wash the entire surface with the thinned blue using the smaller hake. Next, apply the violet on the dark parts of the rocks and let the water carry the pigment upward to blend into the lighter parts. Use a fully loaded no. 16 round to separately drop more of each color on the bottom parts of the rocks. After the colored wash, the masking fluid will be very noticeable. Sprinkle some salt on the tops of the rocks to give them some texture. Let everything dry.

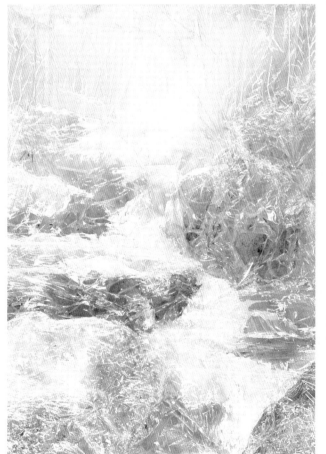

3 Create More Texture on the Rocks

Alternating using Winsor Blue (Red Shade) and Quinacridone Violet, apply color on each rock using a fully loaded no. 16 round. As you finish each rock, cover the wet area with plastic wrap. The objective is to create a unique, somewhat random texture on each rock. Let the paper dry.

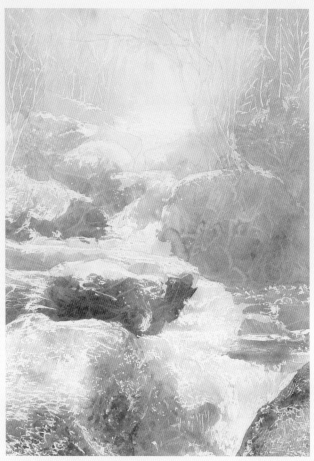

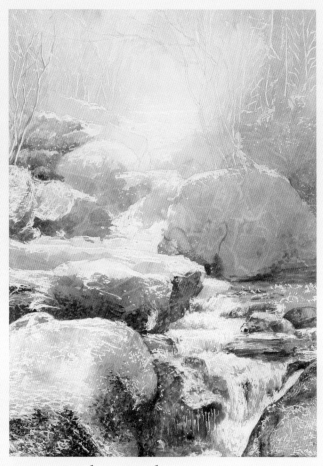

4 Lift the Plastic

Remove the plastic wrap. At this point, the texture is very subtle, and the overall feeling of the painting is somber and quiet.

5 Start Developing Detail

Add Indigo and Sepia to your palette, plus the colors from the separate palettes—Winsor Blue (Red Shade) and Quinacridone Violet—to mix a single, cool, dark color. Using nos. 4 and 10 rounds, apply the dark mixture by alternating dry-brush and glazing techniques to further enhance the texture of the rocks. Glaze thinned Cadmium Red on some of the rocks and for the hint of fallen leaves on the water as an accent.

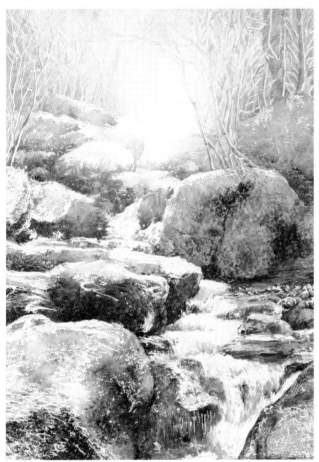

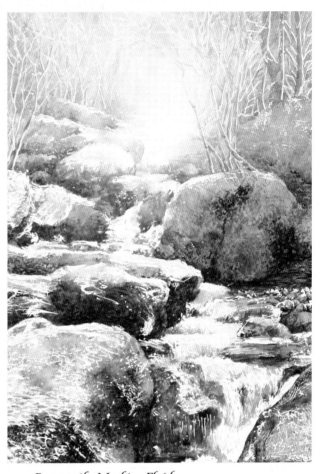

6 Continue the Details

Using the dark color from the previous step, continue developing the rocks, water and trees. Keep the tree area as light as possible to create a source of cold winter light. Let the painting dry thoroughly.

7 Remove the Masking Fluid

Remove the masking fluid, then run a dry hand over the painting to make sure you've left no sticky residue behind (rub gently to remove, if there is any remaining). Some, but not all, of the white areas now appear to stand out too much, disrupting the harmony of the piece. Brush off any remaining salt from the painting.

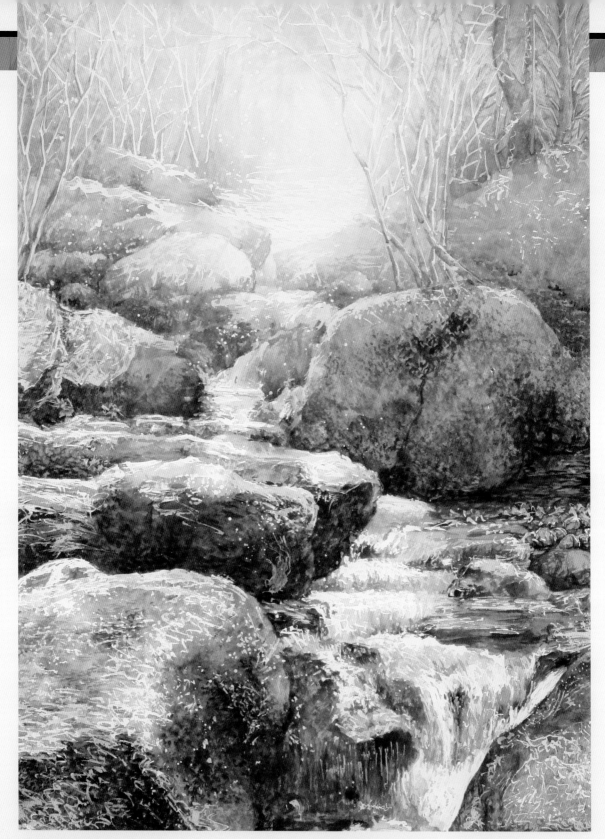

8 Adjust the Values

To harmonize the white areas with the values in the shaded areas, gently glaze over the highlights that stand out too much by smudging the surrounding colors on them with a damp no. 16 round. If necessary, add small amounts of pigment to the brush to complete the process. Adjust values in the painting in this manner, adding color where necessary until you are satisfied.

The randomly sprinkled white spots left after the masking was removed, in combination with the cool blue and purple color scheme, create the atmosphere of a cold winter scene. It gives the impression that the first snow of the season has just started falling.

Winter Creek
Watercolor on Arches 140-lb. (300gsm) cold press
28" x 18" (71cm x 46cm)
Collection of Peter and Alice Haslam

Ensure Brilliant Color With Patient Layering

How many times have you seen a beautiful sunset and wanted to transfer it directly onto paper? The sunsets in Texas are as beautiful as any other place I have ever seen. The burning red and yellow colors spread across the sky as far as you can see without disruption in those wide open spaces. Using the simple technique of layering several colors, a brilliant sunset easily becomes an equally breathtaking painting.

Materials

Arches 140-lb. (300gsm) cold press • masking fluid • nos. 10 and 16 rounds • 2½-inch (64mm) hake • table salt

Watercolors

Da Vinci: Cadmium Yellow Medium

Winsor & Newton: Cadmium Red • Permanent Alizarin Crimson • Sepia • Winsor Blue (Red Shade)

Acrylics

Golden Fluid: Hansa Yellow Medium

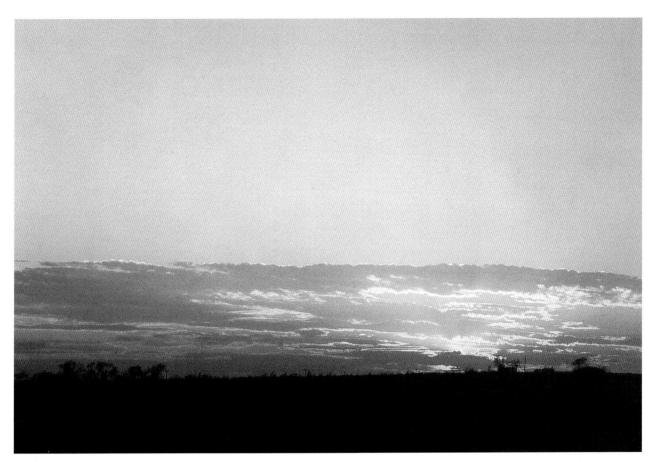

Reference Photo

1 Draw and Apply Masking and the Acrylic Undercoat

Make just a very simple drawing to guide later color application. Then, apply masking fluid to save the highlights on the water and in the clouds and sky. After the masking dries, wet the entire surface and wash the entire paper with thinned Hansa Yellow Medium acrylic using a 2½-inch (64mm) hake. Let it dry.

The advantage of using an acrylic undercoat is that it will not lift off when you glaze the darker colors in the next steps. Opaque yellow, on the other hand, would continuously lift off, creating a murky glaze. The result would be a mess rather than a brilliantly clear, beautiful sunset.

2 Apply More Masking and Another Undercoat

Apply masking fluid on some of the areas to save the light yellow. Then, wash one more time with the same yellow acrylic to deepen the value.

3 Glaze With Red

Using thinned Cadmium Red, glaze the water and the sky. Allow each section to dry before moving on to the next. For each section, start with a no. 16 round that is fully loaded with the thinned paint, allowing it to run freely on the paper within the specific area.

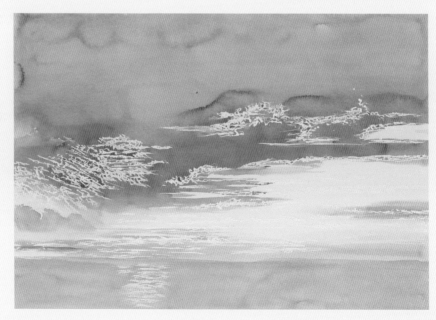

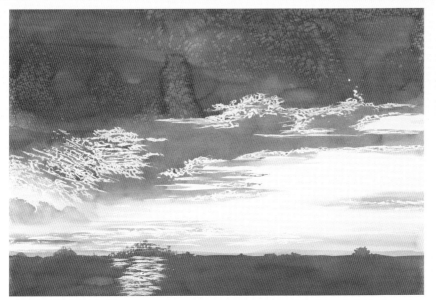

4 Deepen the Red and Make a Change

Apply Cadmium Red on the sky with a no. 16 round and sprinkle on some salt for fun. At this point I decided to replace the water in the reference photo with the vast, flat Texas landscape when a recent sunset inspired me as I rode in my car. The reflection of the water will change into a road in the next step. Apply Cadmium Red on the new land and create small trees and bushes on the horizon line, too.

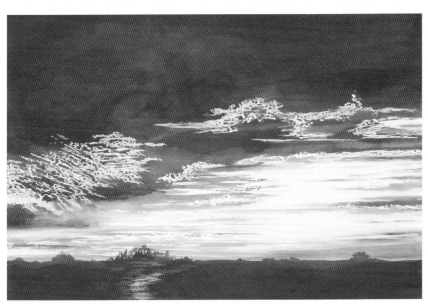

5 Take the Red Even Further

Glaze Permanent Alizarin Crimson with a no. 16 round to deepen the red sky and the ground at the bottom. On the land, remove the masking fluid and apply Permanent Alizarin Crimson around the newly created curved road. The salt effect disappeared with the applied layer, which is fine. After it dries, brush off any remaining salt.

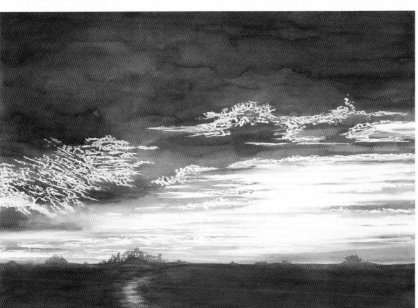

6 Glaze With Blue

Using Winsor Blue (Red Shade), apply a light glaze on the center of the sky and a dark glaze on the top of the sky and on the ground with a fully loaded no. 16 round. Let it drip and puddle to create texture. For the dark glaze, apply it as darkly as you can while maintaining a watery consistency. If the paint is too thick, it will create a dry, streaky texture on the underlying water-resistant acrylic yellow wash. A more watery paint, on the other hand, will create billowy, soft blossoms instead.

7 Remove the Masking

Remove the masking fluid. The stark look of the unmasked whites disturbs the painting's harmony.

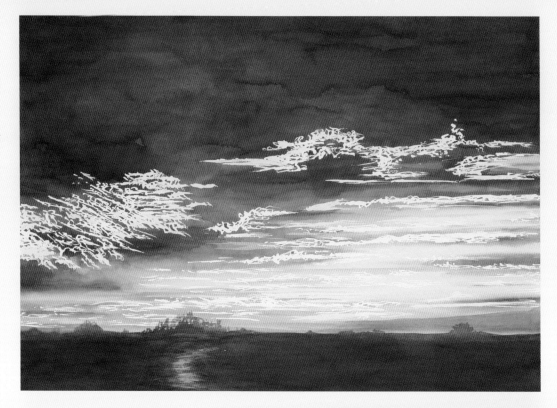

8 Tone Down the Whites

Using thinned Cadmium Red and Cadmium Yellow Medium, glaze the paints, some separately and some mixed, on the upper part of the unmasked white area using a no. 10 round. Leave the white on the right side of the painting, however.

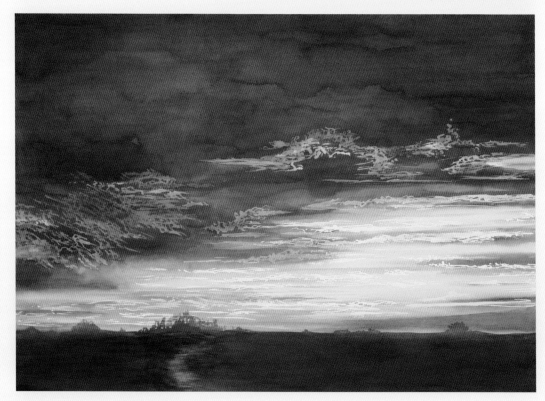

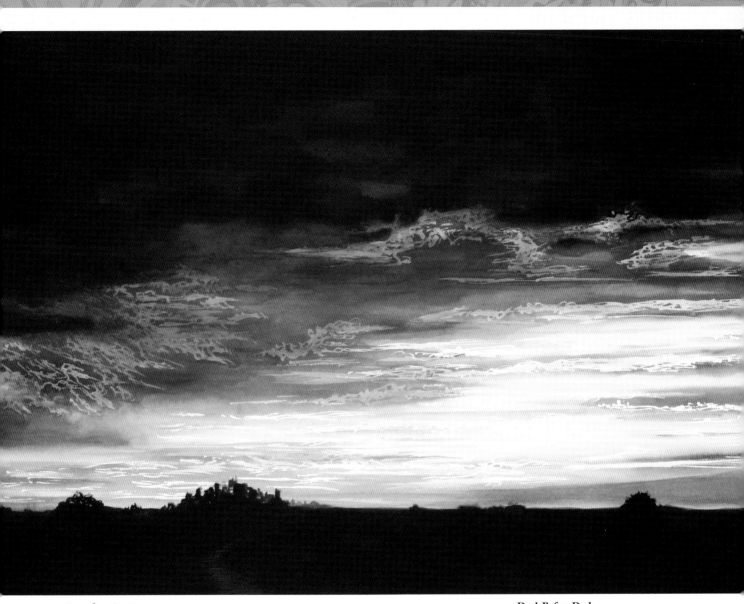

9 Darken for Drama

Create a dark mixture of Winsor Blue (Red Shade), Permanent Alizarin Crimson and Sepia on your palette. On a dry surface and using a fully loaded no. 16 round, gently glaze the ground, maximizing the dark color. Using a clean no. 16 round, wet the sky with clean water. Then quickly apply the dark color with a fully loaded no. 16 round to cover the sky. The wet surface and the dry surface create different results with the same dark mixture. The contrast of the yellow and reddish black creates a warm, brilliant sunset.

Dusk Before Dark
Watercolor and acrylic on Arches 140-lb.
(300gsm) cold press
20" x 28" (51cm x 71cm)

Index

Peony and Glass
Watercolor on Arches 300-lb. (640gsm) cold press
30" x 22" (76cm x 56cm)
Collection of Carolyn and Jerry Doughman

Ideas. Instruction.
INSPIRATION.

Find the latest issues of *The Artist's Magazine* on newsstands, or visit **artistsnetwork.com/magazines.**